# Digital SLR
## MASTERCLASS

# Digital SLR
# MASTERCLASS

photographers'
pip
institute press

First published 2004
by Photographers' Institute Press/PIP
An imprint of Guild of Master Craftsman Publications
166 High Street, Lewes,
East Sussex BN7 1XU

Reprinted 2004, 2005

ISBN 1 86108 358 0
A catalogue record of this book is available from the British Library.

Production Manager: Hilary MacCallum
Managing Editor: Gerrie Purcell
Editor: James Evans

Cover and book design: Fineline Studios
Typeface: Myriad

Colour origination: Icon Reproduction, London, UK
Printed and bound: Kyodo Printing Singapore

**To Tracey, for being there
when I need it most and
for putting up with my
artistic moments**

## Author's Update

The fast-moving developments in digital photography were my main concern when reviewing this book for reprint, but I am pleased to say that my underlying principles and approach to digital photography have remained unchanged and have been supported by many colleagues and peers. The feedback I get tells me the book remains one of the most useful guides for the digital photographer despite technology advancing slightly with the advent of great new digital SLRs like the budget-priced Nikon D70 and the lightning-fast Canon EOS 1D Mark II. Technology will always surge ahead but it is my feeling that the fundamentals in this book will hold true.

One area that has affected me personally is in the area of RAW Conversion software. I now use a product called RawShooter from PixMantia that combines all the features of the group of products that I used to use into one simple package, so my change has been one of sheer laziness! But don't worry, all the editing steps and philosophy from the 'Digital Darkroom' chapter are more valid than ever, and I still use them on a daily basis. I really hope that you enjoy *Digital SLR Masterclass* and that it will both serve to improve and inspire your digital photography as it has mine.

**Andy Rouse**, June 2004

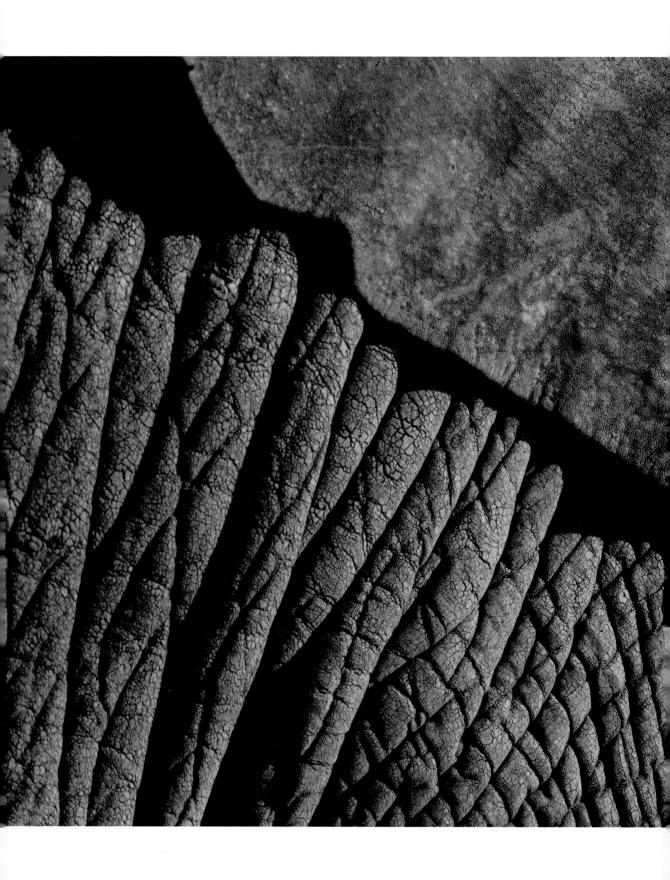

# Contents

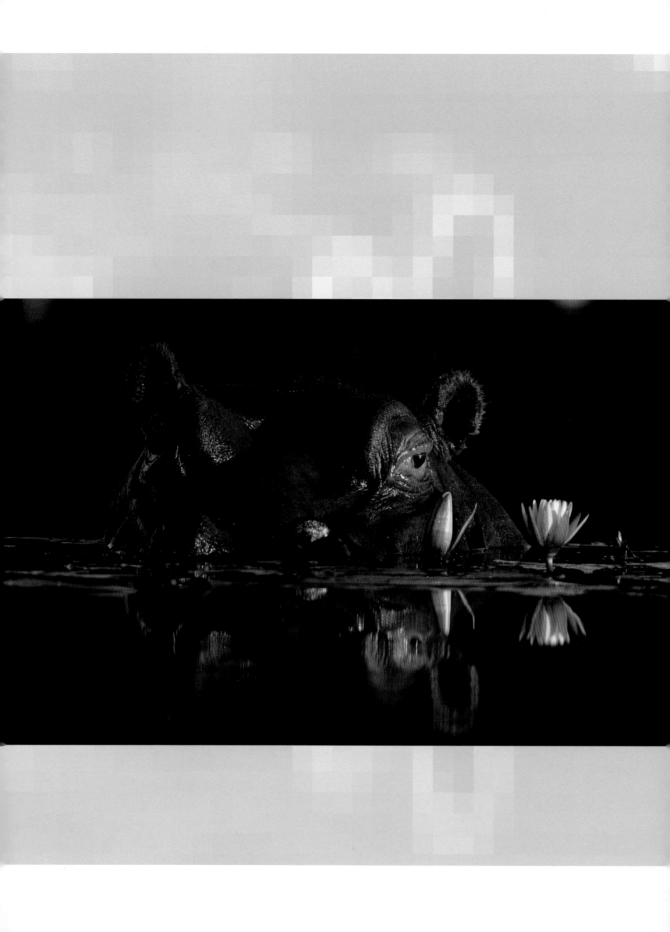

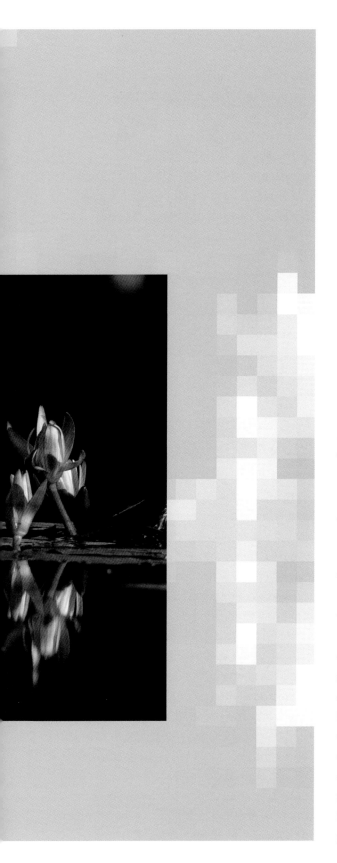

# Introduction

Welcome to the digital age. Whether you like it or not, the world in which we live is a digital one and photography is moving further away from film on a daily basis. Most users in the commercial sector are now entirely digital: press and sports photographers send pictures back to their newsdesks from all over the globe within minutes of taking the shot, and even diehard wildlife photographers like yours truly have made the jump.

This book has come about as a result of the hundreds of questions I have been asked about digital photography over the past few months. There seems to be a tide of photographers who want to make the switch from film to digital capture, but a wealth of unanswered technical questions that stops them in their tracks. As in politics, there is a lot of hype, misinformation and flannel (i.e. the use of 1000 complex words to explain something simple and obvious) about digital capture. Similarly, some of the parties involved seem happy to trade insults that would be more at home in a political campaign than conducting a reasoned discussion. To cap it all, the digital world has more acronyms and confusing terms than Bill Gates has dollars, so it is no wonder that people get confused.

This book concentrates unashamedly on the issues of digital capture using a Digital SLR (or D-SLR) and not on photographic manipulation. It is not that I am against it (far from it), but I am not a PhotoShop expert; I am simply a working professional photographer who uses a D-SLR for all of his work, in a market sector where quality is paramount. I was the first photographer at any of my agencies to submit, have accepted and, more importantly, sell digitally captured images. I am not a digital guru, and don't spend hours pondering and disecting the technology (I leave that to others more qualified). I just use a D-SLR on a daily basis in a professional capacity to get good pictures. I have learnt that although at first glance it appears to be a complex tool, it is actually not that different from the film cameras that I used before. In fact, the major difference is one of approach rather than technology.

If I were invited to write a complete encyclopaedia of digital imaging, I'd refuse. The subject is so diverse, with so many varied (and conflicting) opinions, that I could never complete such a project in my lifetime. However, although there is a lot to learn about digital photography, you do not need to know everything to use a D-SLR effectively.

This book has been written in a way that sticks to the facts and looks at the whole subject from the position of a photographer. Of course, there are technicalities, which I will cover where necessary, but knowing the cause and effect is a lot more useful than knowing the bits and the bytes. It is too easy to get lost in the technology of digital capture and forget what photography is really about: taking great pictures.

This book will cover all the aspects of digital capture: hardware components, D-SLR terminology and set-up, using it in the field, workstation processing and, finally, back-up and archiving. Many existing film users may start to read this book with some trepidation, concerned by the changes that it will make to their photography. Well, don't worry; I'll show you how your D-SLR can be set up to work in exactly the same way as your existing film camera and produce a finished image or 'digital slide' straight out of the camera. Digital-capture photography offers many advantages to the creative photographer, and this book will help you to find out what it can do for you.

## The Evolution of Digital Photography

In truth, digital photography has been with us for many years. Most professionals realized long ago the benefits of sending out scans on CD instead of valuable originals. Initially, however, clients viewed anyone sending out images on CD with suspicion. We were often labelled as manipulators – photographers who did funny things to their images. My reasons for switching to a CD-based library were simple: I could save money on expensive duplicates (which soon mount up when you have several international stock agencies to sell your work) and protect my valuable originals from damage. It often takes me weeks of effort (or seconds of incredible bravery/stupidity) to get one shot, and it is all too easy to drop the resulting transparency into a mug of coffee or run a fingernail across it. Hence the attraction of using CDs to store images.

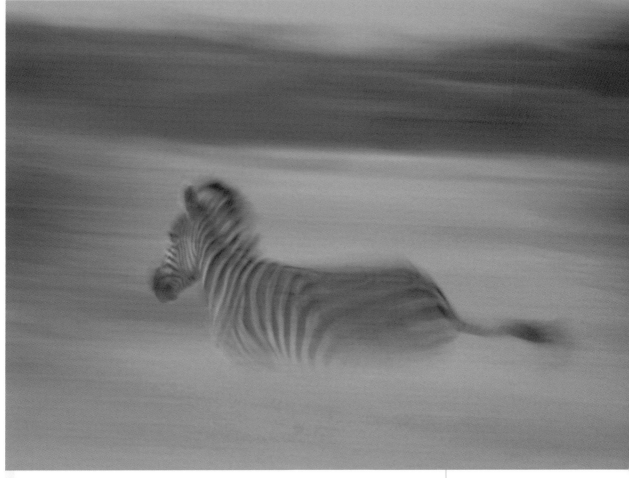

**Fig 0.1**
**My client wanted abstract images that uniquely described the characteristics of the subject. Zebras are born to run, so it seemed natural to me to blur their motion. I would have been reluctant to experiment with film due to the high cost and uncertainty of the results, but with my D-SLR I felt confident to try it.**

Gradually, however, the market has changed and sending out images on CD has become the accepted way of doing business. It makes perfect sense for clients, as having valuable originals in your possession is an insurance nightmare. It also removes the middleman, as previously the slides would need to scanned by a repro house, then the scans would be returned for inspection to the client before being sent back again to the repro house. Now, with scans on CD, the need for this middle scanning stage has been removed, admittedly at a financial cost to the photographer as we have to do the scanning ourselves.

Of course the next logical step came with removing film altogether and using digital capture. Studio photographers were the

first to make the move, with digital backs being produced for their existing medium-format cameras by companies such as PhaseOne and Leaf. The first D-SLR was released onto the market several years ago and immediately started the greatest dilemma (and divide) that the photographic world has ever experienced. To 'go digital' or stay with film has become the most important question since 'does Pepsi taste better than Coca-Cola'.

I remember reading about a cricket photographer who covered an England tour to South Africa. He arrived the morning of the first match and unpacked a prototype Kodak DCS digital camera, hooked it up to his laptop and phone, and sat waiting for the game to begin. As it was the first time a D-SLR had ever been seen in this context, the assembled press corps came over and made a few desultory comments to him. Play began soon after and everyone started work. By that evening, the only person smiling was Mr Digital. He had taken, processed and emailed his shots directly from his seat to make the evening edition of his paper in the UK. Everyone else was a day behind. For the whole of the test-match series, his pictures were first to press and no doubt he made a lot of money out of it.

Urged on by press colleagues, I started toying with digital capture as soon as the first consumer D-SLR was released. I quickly realized the benefits to my work, but was nervous about making the change, as none of my nature-photography colleagues seemed remotely interested in it. The resolutions of the first D-SLRs were too small

for my clients and agents, although later we both realized that this was not entirely true. Slowly but surely my D-SLR images started to sell, and I started to shoot with a D-SLR alongside my Pentax 645 NII system on important trips to Namibia, South Africa and the Caribbean. Everything changed when I was commissioned to record the rebirth of a national park in South Africa on the condition that all my work was shot on a D-SLR. This was partly to reduce overheads, as my bill for 2500 films for the year could be used instead to reintroduce extra animals into the park. As a conservationist, the choice was obvious and I shot the whole project on a D-SLR.

Very quickly, I began to realize the real benefits of using a D-SLR. I'll expand on these as we go through the book, but the main benefits immediately obvious to me were instant review of exposure and amazing capture of detail in low light. For years I had been used to viewing scanned film images on my screen. Now that I had this clear, relatively noise-free image in front of me, I was hooked.

One year on, my 35mm film cameras are stored away in boxes and have been for several months. I still use my Pentax 645 NII medium format for the occasional landscape, but can count the number of film exposures in the last few months on one hand. I've invested in the latest D-SLR technology and now, with my digital sales far outstripping my film ones, my decision has been wholly justified.

**Fig 0.2**
A lovely shot of a young hyena pup taken late in the evening. Shot using a 4MP EOS 1D, popular convention suggests that this image would not reproduce well at this size, but notice the detail in the fur.
Photograph ©
T.J. Rich/ARWP Ltd

# The Digital Advantage

# The Advantage of Using Digital

Here are the factors that lead me to believe that a D-SLR will not only improve your photography, but also make it a lot more fun.

## Instant Review of Images

Polaroid cameras (and Polaroid backs for medium-format cameras) have been around for a long time. The ability to see and change the effect of lighting, composition and filters before taking the final shot always struck me as a great advantage. The only problem with the Polaroid technique was that it took a few minutes for the prints to develop, by which time the scene would have changed (studio photographers excepted, of course). A D-SLR gives you a real-time Polaroid capability via its rear LCD screen, which allows image review within seconds. Although these screens can mislead the unwary, used correctly they can improve your success rate significantly (see pages 101–11).

**LCD screens have other, less obvious advantages too. Consider this picture.**

**This is a very rare shot of a desert black rhino with its calf, taken in a very remote area of Namibia called Damaraland. After several days tracking, I found myself in a deep rocky gully with a mother and calf rhino some 330ft (100m) away. This was a very unusual encounter, with the mother being completely unaware of our presence, and for our safety it needed to stay that way. Using the LCD screen on my D-SLR, I checked the exposure, focus and composition of my first image, made corrections and shot a further 20 variations. I knew that I had the images in the bag, so I made a hasty – if quiet – exit, already thinking of the cold beer that awaited me.**

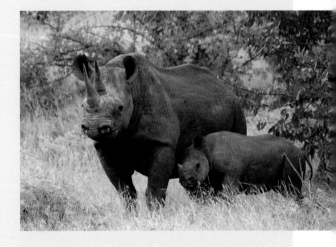

**The moral of the story here is that the D-SLR gave me the confidence to depart before the rhinos learnt of our presence, thus saving stress all round. With a film camera I would have kept taking bracketed sequences and would have been faced with a noisy film rewind,**

which may have ended with me on the wrong end of a rhino horn.

Cynics will say that this takes the skill out of photography. Personally, I see no fun at all in getting images back with the wrong exposure, and surely the skill is in using the correct tools for the job. A D-SLR does not make any picture easier to visualize or compose, nor does it help with subjective focusing and such. All it does is allow the photographer to see how the light meter has exposed the scene, and make corrections before it's too late. As a travelling film photographer, I would often have to wait weeks to see results, with no chance of an immediate re-shoot if I made a mistake. To be honest, my 'near misses' file contained some real shockers. With the D-SLR, however, I can instantly review the shot, delete it if it's poor and then re-shoot – all while still on location. A fellow nature photographer also pointed out to me recently that the chances of returning to the same spot and getting the subject in the same light and pose were as unlikely as a lottery win. Imagine if you were covering the men's Olympic 100m sprint final and got the exposure settings wrong. Could you ask them to run it again? Using a D-SLR you can set the exposure beforehand so that all you need to concentrate on is getting the shot. The bottom line is that with a D-SLR you can confidently capture images as they happen and as you see them. In what way is that removing the skill from photography?

If you are still not convinced about the skill element, consider that the D-SLR can be configured to produce a digital slide – a finished product straight out of the camera. This mirrors what most photographers do now with film, except that with the LCD functions of the D-SLR you can remove most of the guesswork.

## Instant Change of Parameters

Lighting conditions change, and we have all been caught with the wrong film in the camera at some stage. In some countries the weather is so changeable that I have often thought of having two cameras, one for cloudy days and one for the occasional sunny one. The beauty of a D-SLR is that parameters such as ISO rating are treated differently for each shot, and can be changed from one minute to the next without any detrimental effect on the images already captured. This means that you no longer have to carry a marker to highlight pushed films, nor panic when you drop an important pushed film into a bag of normally rated films and are forced to do an expensive clip test of the lot.

There are many other parameters than can be changed for each shot, such as the white balance, which allows you to shoot indoors without carrying bags of correcting filters. I make use of this ability to change shooting parameters all the time, and now it is second nature. In fact, I wonder how I ever managed with film in this respect.

## No More Running Out of Film

This is a sore point for any photographer, especially wildlife and sports photographers. Murphy's Law states that whenever you are changing film, the best shot will happen. I am going to cover 'digital film' a little later (see page 44), but for now just appreciate that depending on how you set up the D-SLR you can get hundreds of shots on each digital film.

## Environmental Issues

Using a D-SLR is much more sound environmentally than throwing away thousands of unused slide films, mounts, plastic sleeves and canisters – all of which just end up being buried somewhere. A D-SLR produces no waste and, what's more, the film is completely reusable. We only have one Earth and they aren't making another one, so we all have to care about such an important issue.

## It's More Fun

Switching to digital has rejuvenated many photographer's interest in photography. With no extra financial cost after purchase, you are free to take as many pictures as you like, and many amateurs also really increase their output as a result.

## Financial Savings

The financial savings begin from the moment you start using your D-SLR, and I know a lot of photographers who have changed to digital capture for this reason alone.

I estimate that I saved thousands in processing, mounting and drum-scanning costs alone in the first year. I asked several amateur photographers who still use film how many rolls they shot on average per year. The lowest was 100, and as things stand (in 2003) the cost of purchasing and developing this number of films is roughly equal to the cost of a new 6.3MP D-SLR. Most take the same lenses as film cameras, and the only extra expense will be the one-off purchase of a memory card (plus an increase in your CD budget). If you scan and print your work now from film, you will probably need no more equipment to step into the digital world. The one saving that you cannot really quantify is time, as your shoot-to-print time will be greatly reduced.

## Dispelling the Myths

**Just like the stories of my fishing exploits, the D-SLR has already been the subject of much myth and misinformation. Here are a few of the common ones:**

*With digital you can cheat and change an image if you want*

**The misconception seems to be that by using a D-SLR to capture images, you can 'cheat' and manipulate them. Granted, a variety of tools can be used to manipulate the image to the limit of your ability. However, the same possibilities exist with a scanned film image or negative – once in digital form it is subject to the same rules as a digitally captured image. The difference is simply that a D-SLR image is already in digital form, while a transparency/negative will lose some of its quality when it is converted into the same medium. At the end of the day, it is your views about manipulation that govern this, and not the medium that captures it.**

*With digital you can just point and shoot because tools like PhotoShop allow you to correct anything*

**While it may seem that you can brighten the darkest picture and vice versa, there is a practical limit to what can be achieved using computer software. If you do not have the detail in the image in the first place, no amount of editing can put it there. You also need to realize that any form of re-touching begins to degrade the image, hence you want to use the minimum amount of correction. Also, we all have better things to do than sit in front of a computer screen.**

**The point that I am trying to make here is that there is really no difference between taking pictures with a D-SLR than a film camera. OK, there is an initial learning curve, but a D-SLR still requires the same level of photographic skill to get a good image.**

# Is Digital Better Than Film?

As I have already said, a D-SLR offers myriad advantages to the photographer. But always the question reverts to a simple one: is the quality of a digitally captured image as good as a film image? My opinion, which has changed the more that I have used a D-SLR, is that with the latest range of D-SLRs it is more than equal to film in terms of quality. I say this as a professional photographer who depends on his clients to pay his monthly rent. If they don't like my images, I don't eat! So if the images are good enough for them, and they are good enough for me, they should be good enough for you. This might seem like

**Fig 1.1**
**Resolution: 3072 x 2048**

**Fig 1.2**
**2048 x 1365**

**Fig 1.3**
**1536 x 1024**

**Fig 1.4**
**500 x 333**

a controversial statement – especially to committed film users – so I will now present some hard facts. To help with this, I will first redefine the basic meanings of 'pixel' and 'resolution', as these important terms will be needed later on.

## Pixel Basics

The heart of every D-SLR is the image sensor, the tiny element that converts the real world into digital form. Think of the sensor as the film plane and you have the general idea, in fact it sits in the same place. The sensor is a wafer-thin array, which is comprised of millions of light-sensitive photodetectors, arranged in a uniform grid system. These points are commonly referred to as PIXELS (PICture ELements) and described as the building blocks of digital photography. (In truth this is not quite the case, as the pixel is actually a combination of the photodetector and its associated circuitry.)

## Resolution

The more pixels that you have in an image, the greater detail it will contain (no rocket science there). There is also another school of thought that says it is not the quantity of pixels, but the size and quality that is important. The number of pixels you choose to have in an image, whether digitally captured or scanned film, is called the resolution. An image with 3072 x 2048 pixels will clearly have more detail, and therefore produce a sharper result at the same print size, than the same image with 1536 x 1024 pixels. The example opposite shows the result

of taking the same image at four different resolution settings.

The maximum resolution a D-SLR sensor can achieve is usually expressed as the absolute number of pixels in the grid rounded up to the nearest number. For example, a grid of 3072 x 2048 pixels gives a total number of 6.29 million pixels, or 6.3 MegaPixels (MP). This has become the de facto standard with D-SLR manufacturers when quoting their highest resolution. The higher the resolution, the bigger the image will print without showing any pixels.

Most photographers will know that film structure is, by definition, based on grain. The higher ISO film you use, the more grain comes to prominence. One thing is sure though – for most of us, pronounced grain in an image is completely unwanted. A digitally captured image, by its very architecture, is based on digital information and cannot therefore suffer from grain. It can, however, suffer from signal noise, which can have a similar effect to grain in film. Fortunately, the latest series of 6.3MP (and above) D-SLRs has addressed this issue to produce virtually 'noiseless' images. I'll cover this issue in greater detail in future chapters of this book.

## The IQ Test

Norman Koren and Miles Hecker have produced a mathematical analysis of this comparison. I want to thank them for allowing us to reproduce their findings here (for more information, see the appendix on page 183). To summarize, they set out to compare a digitally captured image with

### The IQ Test

| Medium | Pixel Array in MegaPixels | Image Quality (IQ) |
|---|:---:|:---:|
| 35mm Fuji Velvia | 21.4 | 0.73 |
| 35mm Fuji Provia 100F | 21.4 | 0.84 |
| 645mm Fuji Provia 100F | 58.4 | 1.75 |
| Canon D30 | 3.1 | 0.54 |
| Canon D60 | 6.3 | 0.78 |
| Canon 1Ds | 11.0 | 1.03 |
| Nikon D100 | 6.0 | 0.76 |
| Kodak 14n | 13.7 | 1.18 |

a scanned film image, in terms of its inherent image quality (tonal range, detail, sharpness, signal to noise ratio). Using a mathematical model, they produced a value called the Image Quality (IQ) to represent this. The table above shows a summary of their findings.

So what does it all mean? Well, let's take the film results first. The effective pixel array for a 35mm film camera is much higher than that of the largest D-SLR at the time of writing. But, as I have mentioned, the effect of grain and of the pure digitized form of the image must be taken into account; even though the slide films have more inherent detail and colour range, the effect of scanning them increases any grain in the scanned version. This has a detrimental effect on the fine detail of the image, reducing the overall quality. The cameras in the table are now slightly out of date, but this simply means that new D-SLRs compare more favourably.

Looking at the IQ figures (above), it is clear that a Canon D60 or Nikon D100 (with IQs of 0.78 and 0.76 respectively) compare very favourably with a scanned 35mm Velvia or Provia 100F image. Of course, these are only approximations and the images are straight out of the camera without any digital manipulation, but the argument about digital capture being 'nowhere near film' in terms of quality clearly doesn't have much substance in the light of these tests. In the case of D-SLRs with 11MP and more, the only superior medium appears to be 645 transparency and larger. This will no doubt please landscape photographers, who will perhaps be the last bastions of film-based photography. Digital capture, however, is more than just a quality issue – the benefits to anyone's photography are numerous. One thing is sure, when you view your first decent digitally captured image on your workstation, you'll be totally convinced.

# A Practical Example

The limiting factor in printing or reproducing a scanned film image beyond its default size is the amount that the grain starts to detract from the image detail. Digitally captured images, with their virtually noise-free construction, should in theory be more expandable than their film counterparts. I first noticed this when using the 3.1MP Canon D30 on a Dolphin calendar shoot in the Caribbean.

To cut a long story short, the D30 saved the day when my other cameras had been damaged by salt water. I sent the corporate client some thumbnails via email and they chose this shot (Fig 1.5) as the cover.

Thinking how small the D30 image looked on the CD among the drum scans (2160 pixels on the longest side, against a whopping 5606 pixels), I decided to keep the client happy and send them anyway. After a month of waiting, a package arrived containing the proofs of the calendar, and there was the D30 dolphin on the cover, reproduced at A3 size. I could not believe my eyes – it looked as clean as a whistle, while the drum scans (all shot on Provia 100F slide film pushed to 200) looked grainy in comparison.

**Fig 1.5**
**Although shot with a 3.1MP D-SLR, producing a frame just 2160 pixels on the longest side, this image retains excellent quality.**

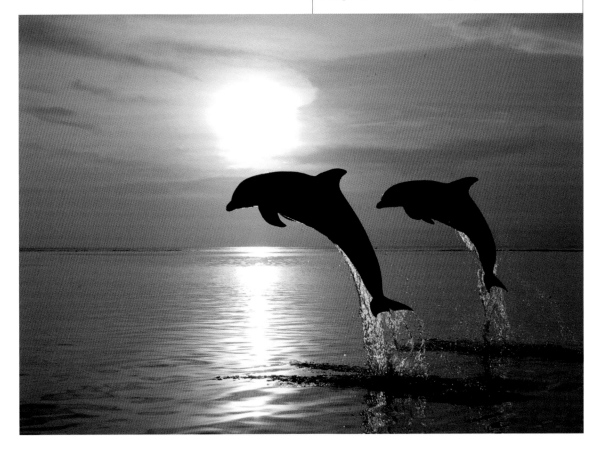

This confused me, as a 5606-pixel drum-scan image should just about make it to A3 in size, whereas my D30 image – at a much smaller 2160 pixels – had reproduced much more successfully. The answer was in the grain; pushing the film to ISO 200 increased the grain, and drum scanning accentuated this even more. The D30 image exhibited no grain and very little noise, even when shot at ISO 200. This experience, and others of having digitally captured images published at A3 and above, has led me to a controversial theory: it's my opinion that digitally captured images can be expanded to a much higher degree than scanned film images. The latter starts to exhibit

displeasing grain soon after it reaches its maximum calculated size (although some grain-reducing tools can help to alleviate this), while the former does not.

## Conclusion

Hopefully, this will have convinced most of you about the relative merits of digital capture compared to film. The main problem now is one of technology, and the initial technical learning curve can seem daunting. In truth, however, it isn't; it is the confusing array of terminology and lack of clear information that makes this learning curve seem so steep. The rest of this book is

*Interpolation – Stretching an Image*

**Ever looked at billboards and wondered what kind of camera was used to get such big images? Well, sometimes they are taken on huge 10 x 8in cameras, but most of the time they have been interpolated from 35mm images. Interpolation is the process of expanding the image by using complex software algorithms to work out how each pixel sits in relation to its neighbours. Extra pixels are then added to the image, hence it can be enlarged. I am going to talk about interpolation programs a little later in the book, but the point I want to make at this stage is**

**that digitally captured images can interpolate as well as – or even better than – their film counterparts.**

**My own experience with interpolation comes from a car dealership in Oxford, UK, which displayed three of my 13 x 9ft (4 x 2.5m) prints on the walls of their showroom. Two were made from D30-captured images (2160 pixels on the longest side), while the remaining one was a scanned 35mm film image. All three images were interpolated using a package called Extensis SmartScale, and standing underneath it's difficult to tell which one is the film image.**

dedicated to describing this technology and explaining it in terms that anyone can understand. I'll cover all the aspects of digital capture, with useful tips and plenty of examples gained from my experience as a professional photographer. As I am completely unbiased, I'll also identify some of the problems with D-SLRs and how to overcome them. Hopefully this will turn a steep climb into a gentle ascent.

**Fig 1.6**
**One of my favourite owl shots: a wild great grey owl gliding down onto its prey. Using the D-SLR screen I set-up my exposure so that it was correct before the owl even took off, allowing me to concentrate on keeping it in focus as it swooped towards me.**

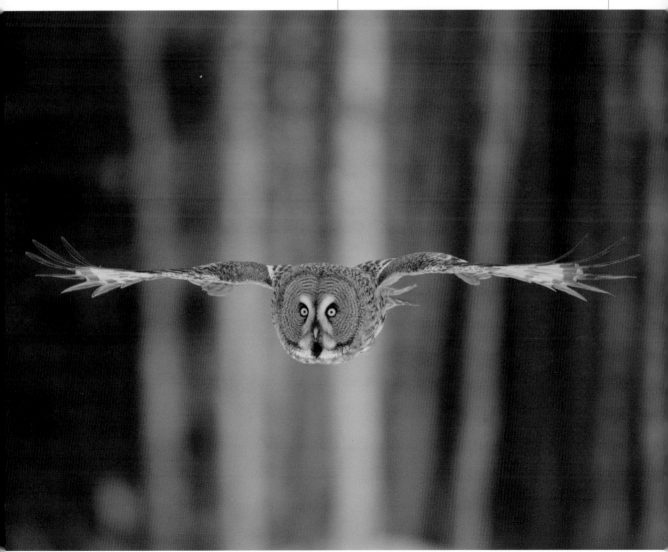

# Technical Operation

# Technical Operation and Key Decisions

At first glance the D-SLR may seem a little overwhelming from a technical point of view, and I had a very steep learning curve when I started using one. The purpose of this chapter is to introduce the technology to those photographers who are new to the world of digital capture. If you are already a D-SLR user, you may want to jump ahead to chapter 3, although some of the sections contained here may act as a useful refresher.

In my experience, the easiest way to understand the concept of digital capture is to think of it as a workflow – a series of logical and connected steps to achieve the finished image. This workflow can be divided into four manageable chunks, and the diagram opposite shows all the essential components of a D-SLR workflow. It is deliberately simplistic to help anyone not conversant with digital technology more complicated than an electric toaster. The starting point of the workflow is your picture idea, and the logical end point is your finished image, which is ready to print or send to a client or friend.

## 1) The D-SLR

The D-SLR's role is to produce an image in your chosen storage format, then write it to digital film. There are two formats for an image: RAW and JPEG. Which one you choose is perhaps the single most-important decision you will ever make when using a D-SLR. Chapter 3 will go into much greater technical detail on the complexities of the RAW versus JPEG question

(see page 56). For the purposes of this chapter, however, a RAW image can be thought of as an undeveloped film from the camera and JPEG as a developed film ready for use. It is important to remember that although the choice of storage format is a parameter that can be changed on a 'per-shot' basis, once selected it is irreversible for the shot that you have just taken.

## 2) The Download

At some stage the digital film will either become full or you will finish shooting. In either case it is time to download your images, store those you wish to keep and clear the card for reuse. If you are at home, you are likely to download to a workstation; if in the field it will usually be to some form of portable storage device (such as a laptop or specialized miniature hard drive). There are four ways of downloading your digital film:

- direct camera connection to workstation via USB or Firewire cable
- place digital film in PCMCIA adaptor and insert into workstation (usually for laptops)
- place digital film in separate hardware card reader, usually USB or Firewire connected to workstation
- transfer images from the card to a portable storage device.

A discussion on the relative merits of each approach will be found later in this chapter (see pages 46–7).

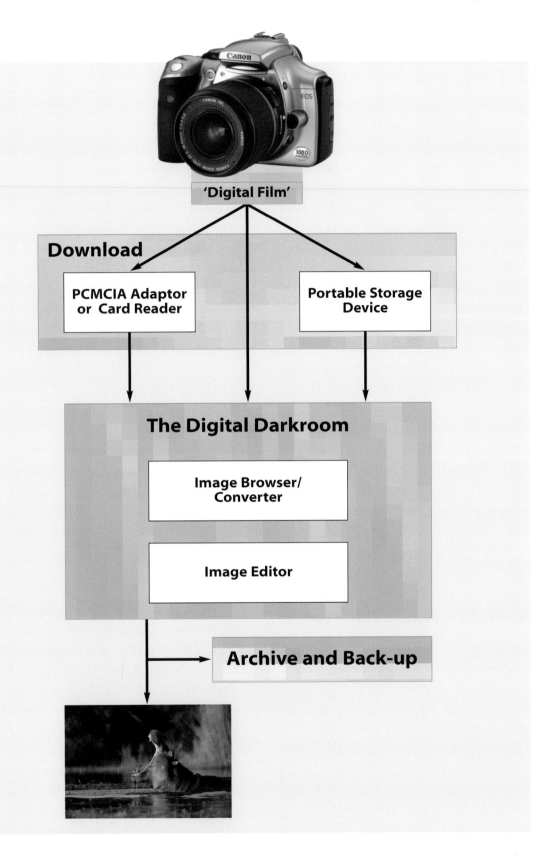

## 3) The Digital Darkroom

This is the workstation component (whether you use a PC or Mac), and can be thought of as the developing stage. Using the range of tools that are now available you can develop, tint, tone, dodge, burn and apply a whole range of techniques to an image that were traditionally restricted to the darkroom. Hence the term 'digital darkroom'.

The main advantage of a D-SLR for most photographers is that it costs nothing to take pictures after you have bought it. This means that you invariably take a lot more pictures than you may have done on film, and it is certainly true that I have become much more prolific since switching to digital capture. This in turn means that you need to be much more disciplined when it comes to editing your images, in order to separate the good from the bad (from the very bad indeed). Later in this book I'll outline a simple hierarchy for ensuring that you only keep the best images, and do so with the minimum of time and fuss (see pages 132–5).

## 4) Archive and Catalogue

Digital capture is the world of the single-key delete (usually followed by a stream of expletives). Hard drives can and do fail (believe me), so having a good archive and back-up solution is vital. This isn't as complex as it sounds, and several archive solutions also provide great ways of cataloguing your work. A chapter on this (see page 165) is included to help you protect your valuable images.

# The D-SLR Technical Overview

All D-SLRs are not born equal in terms of functionality, but internally they all look roughly the same. The diagram opposite shows a deliberately over-simplified illustration of the camera's basic structure. It is not essential to understand all of this in order to take digital images, but there are some useful points to know about, both in terms of assessing a new purchase and also operating a D-SLR in the field. The three key areas that I want to cover are:

- sensor types
- sensor size evolution: cropped and full frame
- buffer size and implementation.

## Sensor Types

Sensors can be divided into two main categories: Mosaic and Foveon X3.

### Mosaic Sensors

Mosaic sensors are so-called because each photodetector is contained in a grid system. A simple explanation of the process would be that each photodetector measures the amount of light falling on it and converts this into electric charge, which is processed to give image data. The grid can be seen right (diagram courtesy of Foveon Inc).

Each photodetector sensor can only measure the amount of light falling on it, so it is effectively colour-blind. To solve this, a grid of red, green and blue filters is applied at the

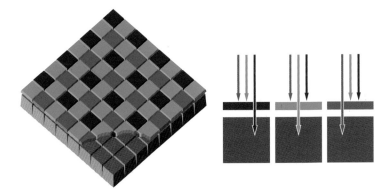

## Mosaic Capture

In conventional systems, colour filters are applied to a single layer of photodetectors in a tiled mosaic pattern.

The filters let only one wavelength of light – red, green or blue – pass through to any given pixel, allowing it to record only one colour.

As a result, mosaic sensors capture only 25% of the red and blue light, and just 50% of the green.

manufacturing stage to sit on top of the photodetector grid. Each of these photodetectors thus sees varying amounts of red, green or blue light, depending on which colour filter sits above it. Complex software processing then takes into account the values from near neighbours, to come up with an RGB (Red, Green, Blue) colour value for that photodetector.

There are two types of Mosaic sensor: CCD (Charge-Coupled Device) and CMOS (Complimentary Metal-Oxide Semiconductors). CCD has been around since the inception of silicon technology and was always thought to produce the best quality, although at a high production cost.

CMOS, on the other hand, was always the cheaper, mass-produced alternative, with lower power consumption but poorer image quality. A year before this book was written, most of the D-SLRs on the market contained a CCD sensor. Nowadays, technology has

improved enough for CMOS sensors to be widely available and a viable alternative to CCDs. In fact, the latest D-SLRs all use CMOS sensors, even the EOS 1Ds, which has been widely acclaimed for the high quality of its results. Due to their lower power requirements, CMOS sensors give their D-SLRs much better battery life, something that cannot be ignored (see page 121 for hints and tips on this). Hopefully, the lower production costs should be passed on to D-SLR buyers as lower prices (but I'm not holding my breath).

**The Foveon Sensor**

Foveon is the new kid on the block, and has created a lot of interest from the media and photographers alike. So what's the big deal? Well, instead of having a single layer of photodetectors with a single-colour filter on top (like the Mosaic sensor), the Foveon has the multi-layered system shown below

# Foveon Capture

**A Foveon image sensor features three separate layers of photodetectors embedded in silicon.**

**Since silicon absorbs different colours of light at different depths, each layer captures a different colour. Stacked together, they create full-colour pixels.**

**As a result, Foveon sensors capture red, green and blue light at every pixel location.**

(diagram courtesy of Foveon Inc). It is easy to see how the Foveon sensor should capture more colour and detail within an image, as each pixel effectively sees all three primary colours, whereas a Mosaic filter sees only one. It also has the potential to produce sharper results. (For more details, see the Foveon website, page 183.)

> **The diagram below illustrates the impact of using a cropped sensor, which (as explained overleaf) effectively increases a lens's focal length.**

# Sensor Size Evolution

To confuse the novice user even more, sensors not only come in different designs but in different sizes: cropped and full frame.

## Cropped Sensors

In most consumer D-SLRs today, the sensor is slightly smaller than that of a 35mm frame, as shown in Fig 2.3. At first glance, it looks as if a D-SLR with such a sensor cannot produce images of the same quality as a 35mm

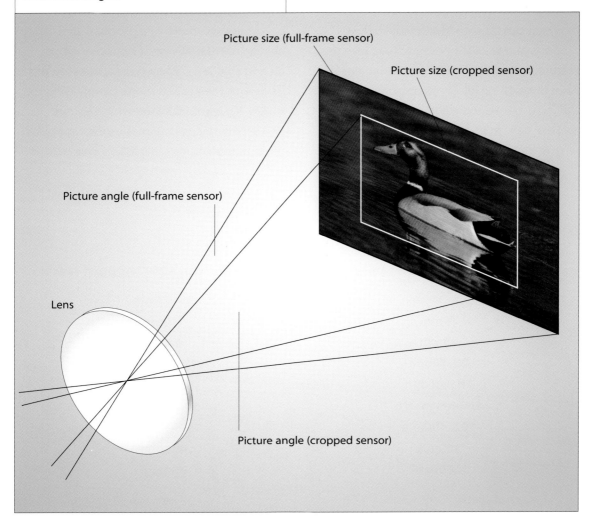

Picture size (full-frame sensor)

Picture size (cropped sensor)

Picture angle (full-frame sensor)

Lens

Picture angle (cropped sensor)

full-frame image. In terms of physical size it is certainly smaller, but in chapter 1 I showed how the Canon D60 and Nikon D100, both of which have cropped sensors, gave favourable results when compared with scanned Fuji Provia 100F film (see page 22).

One of the effects of the cropped sensor is that the focal length of your lens is effectively multiplied, and this is something that I find to be a great advantage. This is in truth an internal image crop, but the end result is that your lens suddenly becomes slightly longer. Most D-SLRs that fall into this category have a 1.5x effective focal length mutiplier, the effect of which can be seen in the table below.

Sports and wildlife photographers love this feature, as we get effectively a longer lens from our existing kit. For example, instead of adding a 1.4x teleconverter to my 500mm to make a 700mm f/5.6 lens, I can use the D-SLR to give me a 750mm f/4 lens – a longer lens

that is one stop faster. Not only that, but in the case of a 300mm lens, this produces a 450mm lens that can easily be hand held, which cannot be said of most 400mm-plus lenses!

Unfortunately there is a flip side. Landscape photographers suffer as a result of this effective increase, because a wide-angle 28mm lens now becomes a 42mm lens. This is a major bone of contention with pros and amateurs alike. Achieving an effective 28mm lens requires the use of an 18mm lens, which may add distortion problems due to the super wide-angle effect. Taking super wide-angle pictures with 17mm or wider lens becomes even more of a problem, and heaven only knows what happens with a tilt and shift lens. Nikon have addressed this issue with their D-SLR range by releasing the Nikkor 12–24mm DX lens, which equates to an 18–36mm lens in 35mm terms. No doubt other manufacturers will follow suit.

### Cropped Sensors: Lens Focal Length

| Focal length with film camera | Focal length with APS-C cropped sensor |
|:---:|:---:|
| 17–35mm | 25–52mm |
| 20mm | 30mm |
| 28mm | 42mm |
| 28–70mm | 42–105mm |
| 70–200mm | 105–300mm |
| 100mm macro | 150mm macro |
| 100–400mm | 150–600mm |
| 300mm | 450mm |
| 500mm | 750mm |

## Full-frame Sensors

Currently there are only a handful of D-SLRs with full-frame sensors on the market. These sensors have a 1x effective focal length multiplier, which pleases everyone except the sports and wildlife crowd. But while the full-frame sensor delivers much increased resolution, it has some inherent problems (although these are nothing to do with the camera itself). Wide-angle lenses have traditionally been manufactured with a slight curvature, with the sharpest point or 'sweet spot' in the central portion of the lens where it is flattest. The outer edges of such lenses are increasingly curved, which is fine for film as it can handle light falling onto it from all angles. At the very extremes of a wide-angle lens (just as it touches the barrel in fact) the quality of the lens is at its worst. Again, this is fine if you're using a film camera, as the lens curvature directs the incident light away from the film edge. Unfortunately, the super-sensitive array of a full-frame sensor readily picks up these inadequacies.

The sensor has trouble resolving the light falling on it through the most curved parts of the lens (i.e. at the edges), and this can be seen in the resultant full-frame images as blurriness around the extreme edge. Other effects of this are seen as chromatic aberration under certain light conditions. A cropped sensor doesn't have the same issues because its reduced field of view only uses the flatter central portion of the lens.

**You can still use your existing wide-angle lenses. Those of you with cropped image sensors will not notice any of the problems inherent with wide angles. For anyone with a full-frame sensor there are a few options for overcoming these problems, although it will require extra time and effort. You could crop the edges from your images in the digital darkroom and then enlarge or interpolate them, invest in a new digital-specification lens, or simply stand back and use a higher focal length (and therefore less of the extremes at the edge of the lens). Most industry commentators agree that when the focal length is greater than 24mm, problems with blurred edges seem to be much less apparent.**

## ......The Bottom Line

This is not to say that full-frame sensors should be avoided, but it does suggest that sensors have now moved ahead of existing lens technology and that a fresh approach needs to be taken in order to address this.

## An Industry Standard: Four Thirds

Until recently, camera manufacturers simply adapted their D-SLRs to fit their existing 35mm lenses. Many users face a simple yet frustrating choice, as each camera manufacturer has its own standard lens mount, which means those of us with lenses of a single make are restricted to that manufacturer's D-SLR offering. Even independent lenses like Sigma, Tamron and Tokina have a proprietary fit. Remember the days of the Tamron Adaptall-2 system when you could just buy a new mount?

Kodak and Olympus have signed an agreement to implement a new open standard for digital cameras called *Four Thirds*. Importantly to photographers, it allows a common lens-mount system. The main marketing angle is that the Four-Thirds system is the first to be designed solely for the needs of a digital photographer. So far a number of manufacturers have pledged their support for the Four-Thirds protocol. However, relatively few products have actually hit the shelves, and whether Four Thirds becomes successful depends a great deal on whether it becomes popular enough to encourage a large number of manufacturers to commit to producing Four-Thirds products.

There are three issues that need to be considered with Four Thirds. The first is that the widened lens mount means that you will have to start your lens collection from scratch. The second is that as things stand you may be restricted to using a Kodak sensor in your D-SLR (how this affects manufacturers like Fuji that have invested heavily in their own sensor technology remains to be seen). The final issue is where Foveon fits in, as they have

a patent on their sensor and at this early stage their technology seems likely to become a major force in the market. Time will tell on all of these issues, but the principles and ideology behind Four Thirds needs to be applauded, as increased competition is great for photographers. Also, one benefit of lenses designed specifically for use with D-SLRs is that they are smaller and lighter than existing film-camera lenses.

■ Fig 2.2
The Olympus E-System – the first professional D-SLR to be based on the Four-Thirds Standard. All of the system's components and accessories have been designed specifically for digital use, and increased competition as other manufacturers produce their own purpose-built digital solutions should benefit D-SLR users .

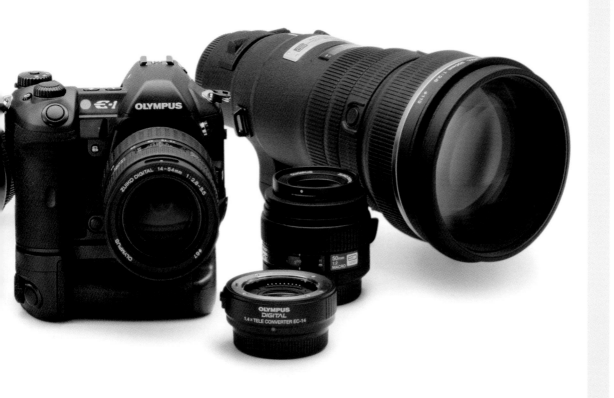

## Digital Specification Lenses

**Several manufacturers, notably Nikon, Canon and Tamron, have released new 'digital-specification' lenses that have been specifically designed for the needs of D-SLRs. In basic terms, they all address the issues by having flatter lens elements and higher-specification manufacturing of the glass. These lenses have proved useful to wide-angle photographers, and more will no doubt be released over time.**

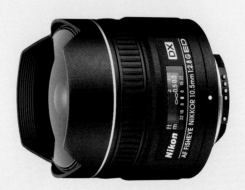

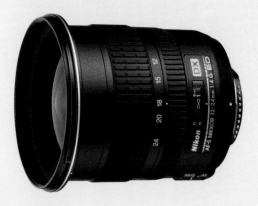

■ **Fig 2.3**
**Digital-specification lenses: Tamron's AF180mm macro (top) and AF28–75mm zoom (top left), and Nikon's DX Fisheye-Nikkor 10.5mm (above) and DX Zoom-Nikkor 12–24mm (left).**

## Summary

- There are two main sensor architectures: Mosaic and Foveon. At present Mosaic sensors are the norm, and while Foveon is considered to offer several advantages, it is still in its infancy and not widely available.
- Mosaic sensors come in two forms: CCD and CMOS. There is little to choose between these and as they are not interchangeable you're stuck with the one you have.
- Sensor sizes can be cropped or full frame. Cropped sensors increase the focal length of existing 35mm lenses by a factor of up to 1.6x. Full-frame sensors have no effect on focal lengths but suffer from problems caused by the curvature of wide-angle lenses designed for film cameras. Several manufacturers have produced lenses specifically designed to address this problem.
- Many consumers have relatively little choice in the D-SLR market but to stay with their existing manufacturer. Recently, more models have become available with a greater variety of lens mounts. Olympus has introduced the Four Thirds protocol, an open standard for the D-SLR industry.

# Buffer Considerations

When you press the shutter button, the D-SLR processes all the data from its sensor grid to record an image. Writing this image to digital film is a slow process, and to protect the integrity of the stored images the D-SLR effectively disables your ability take any more shots during this period. This is known as 'lockout'. If D-SLRs were designed in this way, the process would be take a shot and be locked out, take a shot and be locked out, and so on. This would be very frustrating, and personally I'd end up taking a hammer to the camera.

Fortunately, D-SLR manufacturers all incorporate a temporary memory buffer. Writing to this is a lot quicker than writing to digital film, and so it is used to act as a middleman and minimize the effects of lockout. The buffer holds a finite number of images and allows the photographer to carry on shooting until it is full. At this point, or if the D-SLR detects that your picture-taking has finished, lockout occurs and your images are written to digital film.

The number of images that the buffer can hold at one time is called the 'burst size'. This varies depending on the type and style of the D-SLR in question. For example professional sport-based D-SLRs will have larger buffers than consumer models.

Most D-SLR users overlook the buffer, thinking that it does not really matter. In truth this is an oversight – knowing how the buffer works allows you to manage it better and helps to avoid missing pictures during lockout.

Different manufacturers have implemented their buffers in slightly different ways. A dual-buffer system is the best, as it allows you to continue shooting for longer.

A dual buffer, which is implemented on the Canon EOS D-SLRs, works in the following fashion. When you shoot continuously the

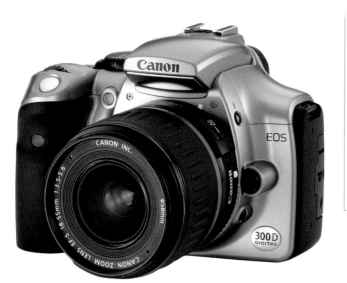

**Fig 2.4**
Examples of some of the range of digital SLRs currently available: the Canon EOS 300D (left), the Nikon D2H (below), and the Pentax *istD (bottom). As covered on page 39, each camera offers a different burst size, and each also has a different sensor size – 4.1MP for the D2H, compared to 6.5MP and 6.1MP for the EOS 300D and the *istD respectively.

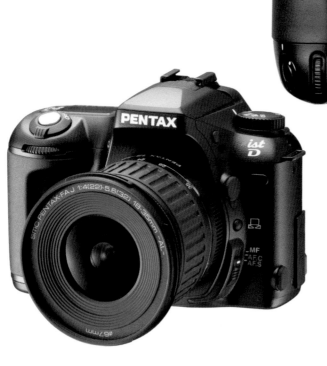

Writing image data to the memory buffer is a lot quicker than writing to digital film, and so it reduces the effects of lockout. These examples of a D-SLR's displays show that the buffer has six shots remaining before it is full and lockout will occur.

buffer gradually fills up with images until it reaches the maximum burst size. When this is reached the buffer is full. If the D-SLR detects that shooting has finished then the images are written to digital film. Up to this point this is the same as a single buffer. However, with a dual-buffer system, if shooting continues the D-SLR processes the images in the buffer to create either developed JPEGs or undeveloped RAWs. This frees up space, which can be used to take more pictures. Of course, there is a limit, and when the buffer is totally full lockout occurs and all the images are processed and written to digital film.

## D-SLR Feature Summary

All of us, whether an experienced professional or a novice user picking up a digital camera for the first time, have certain requirements from a camera. No camera will ever do everything that we want of it, so it's always a question of compromise. A D-SLR is no different and it's important to be honest

with yourself and decide exactly what you need. If you're a full-time professional in an area where resolution is paramount, perhaps landscape or wildlife, then a full-frame D-SLR is currently the only option. If you are in the area of sports and press photography and therefore need high throughput, the only realistic options are the Canon EOS 1D and Nikon D2H. That covers approximately 0.01% of digital camera users, so what about the rest? The simple rule is to buy what you can afford and what you need. The current crop of 6.3MP D-SLRs offer cracking image quality, great prints at A4 and beyond, offer all the features that you will ever need (and a lot more that you won't) and are sensibly priced. The latest release, the Canon EOS 300D (Digital Rebel), breaks new ground in terms of price, and will surely be joined by many others. If you cannot stretch to this then the new range of 'prosumer' digital compacts, such as the Canon G5 and the Sony DSC-V1, offer great functionality and prints to A4. For many users these cameras will offer

**Fig 2.5**
This image was shot using a prosumer digital
compact (the Canon G5), and shows superb
quality even when enlarged to A4. I was able
to take it at a low angle by using the LCD
screen to compose the picture.

everything they will ever need and there may be no need to move up to a D-SLR. Whatever system you choose, it will certainly be surrounded by a lot of hype, so it pays to check out the reviews in photographic magazines and Internet review sites (see the appendix on page 183 for details). At the end of the day your choice will probably be governed by your existing lenses (they will work on a D-SLR), but it might also be worth taking a look at what is on offer as it might be a good time to change system anyway.

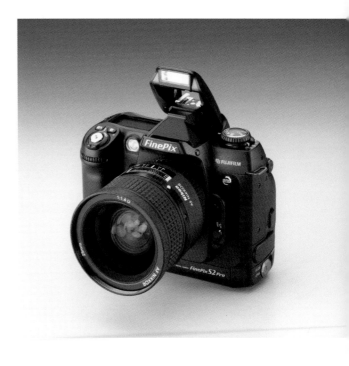

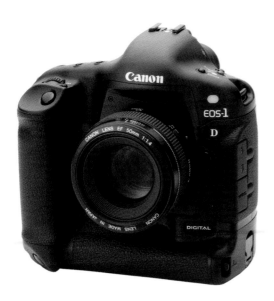

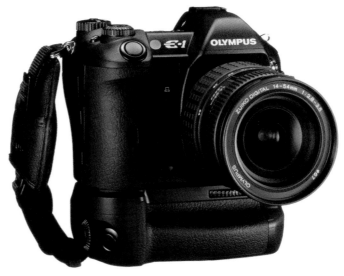

**Fig 2.6**
**Fuji's S2 Pro (above right), Canon's EOS 1D (above) and Olympus's E1 (right). The range of D-SLRs on the market is so large, and so fast developing, that it pays to research thoroughly before buying. Your choice of make may be governed by your existing lenses, but Four-Thirds (as used by the E1) may change this by introducing an open standard for digital SLRs.**

# Digital Film

The small removable and reusable card that stores your images in a D-SLR is your digital film, the correct industry term for which is 'storage media'. Personally, I prefer the term 'storage card' and will use this from now on. There are many types of storage card, but the two most popular are CompactFlash (CF) cards and IBM Microdrives. The main difference between the two is that the CF card uses solid-state technology (i.e. no moving parts), while the IBM Microdrive is, as its name suggests, a miniature hard drive. Much has been made of their differences, mostly in the conflicting claims of their manufacturers.

The main advantage of the IBM Microdrive is that it offers the best megabyte value for money, as high-capacity CF cards are not cheap. The issues with IBM Microdrives are well documented and are summarized in the table opposite.

CompactFlash cards have few of these disadvantages. The solid-state design means that the temperature, power usage and shockproof issues are less of a problem than with IBM Microdrives. The main issue with CF cards is one of price – per megabyte they are much more expensive than Microdrives.

Speed is also a vital issue. The quicker data can be written from the buffer to the storage card, the fewer lockouts occur. CF cards have always been slightly faster than IBM Microdrives, and most CF manufacturers offer 'ultra-fast' versions of their cards. These are more expensive, and unless you really need high throughput, a cheaper alternative will suit you just as well.

Another type of card worth mentioning is the SD card. Some new D-SLRs are turning towards these whether as the only storage device or as a back-up storage device. At the time of writing the performance of SD cards has improved to the point were it almost rivals that of CF cards.

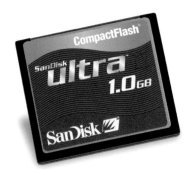

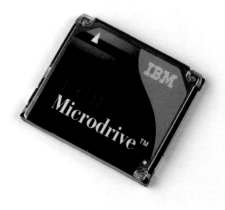

**█ Fig 2.7**
**The two main types of storage card: an IBM Microdrive (right) and a CF card (above). Originally offering lower capacity than a Microdrive, high-capacity CF cards are now available – at a cost.**

## Microdrive Problems

**Excessive heat generation**

All hard drives get hot, and the Microdrive is no exception. The problem with the Microdrive is that it is sited next to some very heat-sensitive components, in particular the sensor. Some manufacturers have now taken the step of recommending against using a Microdrive in their D-SLRs for this very reason.

**Fragile technology**

If you shake a Microdrive it rattles. Personally, I do not like my precious images rattling. The Microdrive is comprised of moving parts, and can be susceptible to damage from shock. Some CF manufacturers have accentuated this by saying that their cards are shock resistant. Sounds great on paper, but unfortunately the shockproof storage card sits inside a completely non-shockproof D-SLR. Drop one and it won't bounce!

**Low operating temperature range**

The specifications for the Microdrive put its operating temperature range from 0 to 65°C. This is great for sun worshippers, but not so good for the thermal-underwear brigade. I know for a fact that at low temperatures the Microdrive can become unreliable – while working in Finland mine often 'froze' and stopped working at temperatures below –10°C. Conversely, I used it in –40°C on top of the Rockies and it performed perfectly.

**Greater power usage**

All hard drives use power to spin up and perform read/write operations. The power consumption of an IBM Microdrive is not negligible, and most experts believe that it drains a D-SLR battery quicker than its counterparts. I have not noticed this myself, but it is very difficult to judge without a formal test.

## Summary

The minimum card size that you should choose is 512MB, with 1GB being the preferred option. If you use a larger card then you just need to get into the habit of downloading all images to the workstation when you have finished shooting, rather than waiting until the card is full (which could take several months if you shoot JPEGs). One word or warning: when buying high-capacity cards check that your D-SLR supports their FAT 32 disk requirements; older D-SLRs certainly do not.

### Pro Tip

**Whichever storage card you choose, get used to downloading images from the card at the first available moment. I'll cover ways of doing this in the field using a portable storage device later in the book (see pages 119–20).**

### Pro Tip

**Look after your cards. Use a memory-card wallet (available from Lowepro) to protect them from dust, and for peace of mind always keep one stored in the camera. I have walked out the door, got to a shoot and realized that my card was still in the reader attached to my workstation. Don't make this mistake – for a start, it's embarrassing.**

## Downloading Images

Getting the images from your storage card onto your workstation is called the download stage. There are three main ways of achieving this, and pros and cons of each method are shown opposite.

As you can see from the list, the cheapest and simplest solution appears to be to connect the camera directly to the workstation via the supplied USB or Firewire cable. The one concern with doing this is that you will be placing excessive strain on the D-SLR connection. If this fails it will be a costly repair. By far the most commonly used option is the final one in the table, the hardware card reader. These devices are available in either Firewire or USB 2.0 and can usually read a wide range of storage media.

**Fig 2.8**
**One way of downloading images is to use a PCMCIA adaptor. The version shown below is for use with IBM Microdrives.**

| CONNECTION METHOD | ADVANTAGES | DISADVANTAGES |
|---|---|---|
| Direct camera to workstation connection | No extra cost<br>Simple<br>Fast | Potential for expensive camera repairs as a result of excessive wear of components |
| PCMCIA adaptor | Small, portable<br>No camera connection | Extra Cost<br>Fragile<br>Mostly only for laptops |
| Hardware card reader | Speed – the fastest of the bunch | Extra cost (although this is not substantial) |
| Portable downloader | Speed – generally USB 2.0<br>Portability | Expensive |

**Fig 2.9**
The most popular method for downloading images: a hardware card reader (above and left). These are available from many manufacturers and can be used to download images from all forms of storage card. The downside is the extra cost, but by connecting directly to your workstation, they are the fastest option.

# Workstation Choice: Mac versus PC

In the same vein that the choice between film and digital have caused controversy, so too does the question of Mac versus PC. It is certainly true that Macs were the machines of choice for the graphics industry, as they had everything a designer could ever want: system-integrated colour management, high system RAM and fast processor speeds. PCs were always seen as tools for the office worker and, more latterly, computer-game players. More recently, PCs have finally caught up with their Mac counterparts and offer identical functionality and peripherals. Macs also seem to be climbing in price and shrinking in functionality, while PCs are getting more loaded for a budget cost. Microsoft XP offers some levels of integrated colour management and there are now plenty of PC-compatible tools and devices to help with this. To be honest, it doesn't matter which system you use; it is what you put inside it that counts. For the record I use a Dell Dual Xeon Processor PC Workstation and have never felt the need to use a Mac.

## Minimum Specifications

In much the same way as your choice of D-SLR is probably already governed by existing lenses, your choice of workstation may have been made already. Most of you will have a workstation of one form or another, and it is probably fair to say that most of you will have a PC. The more dedicated among you will have a stand-alone workstation that is used solely for graphics, with a separate PC for the Internet, home accounts and so on. I have such a system, but suspect it may be a little overboard for an average D-SLR user.

Before I frighten away computer novices, let me assure you that most modern PCs (those made since the year 2000) and Macs (of any age) will be perfectly sufficient for your digital photography. This area in particular suffers from jargon overload, so the following section outlines some minimum requirements to provide a good-standard workstation for digital imaging. This solid foundation can then be built on as your digital photography grows. Technology is advancing at such a pace that, by the time you read this book, things are likely to have moved on from the time of writing. But the information contained here is as up-to-date as it possibly can be.

## Processor Speed

No prizes for guessing, but the faster your workstation the better. If you are using RAW files, you'll be doing a lot of intensive processing work. Any workstation made in the last five years will probably do, but it is a sure bet that those made within the last 12 months will be much faster.

Top of the tree (at the moment) are Mac G5 dual processors and PC Xeon dual processors. These are both really fast and are used for movie editing. Having dual processors means that the workload is spread between the two CPUs, which in turn produces vastly increased throughput.

The downside is – as ever – the extra cost. PC users have the choice of either AMD Athlon or Intel Pentium/Xeon processors, and to be honest it doesn't make much difference. Speed, however, does, so try to buy a PC with greater than 1GHx. Anything in the iMac series will be great, as will any G4 or G5 (and even the old G3s).

For those of you with existing workstations that are below this specification, it may be possible to upgrade your processor card to a newer (and faster) model. The best bet is to speak to your manufacturer about this and not just buy something on the Internet.

## RAM

RAM (Random Access Memory) is a key requirement for image editing. The more you buy, the faster your workstation can process graphics. For example, as a rule of thumb Adobe PhotoShop requires RAM of four to five times the size of the file that is being edited. For my EOS 1Ds, which generates a file size of 31MB, this means approximately 130MB of RAM. As D-SLR file sizes are increasing with each new model, it is better to buy something that is too big now and grow into it. If you have an existing workstation, installing new RAM, assuming that you have the hardware capability, is easy.

It is also as well to remember that even though you may be shooting predominantly JPEGs, there will be times when you use the RAW + JPEG option (see page 67). This means that the minimum you should run with for a 6.3 MegaPixel D-SLR is about 128MB or, even better, 256MB (if you can afford it and have the slot space). For a full-frame D-SLR, a minimum of 512MB is needed to ensure that most of your time is spent working productively rather than waiting for the workstation to catch up.

Video RAM also plays an important part, as this governs the speed at which images are displayed on your monitor. Most graphics cards now have a standard 4MB or more, which is more than sufficient for any digital photographer's needs.

## Hard-drive Space

Hard-drive space is becoming less of an issue these days, as most new workstations are supplied with in excess of 40GB. Of course, your imaging and system programs take up quite a chunk, as will your finished data. The average 6.3 MegaPixel D-SLR converted RAW is approximately 18MB in size, which means 100 files take up 1.8GB. At this rate, if you are not disciplined your images can quickly consume all of your hard-drive space.

**Use a PC with a minimum Pentium III or AMD Athlon XP, or a Mac that was made after the mid-1990s and is not falling apart.**

# ......The Bottom Line

**Have a minimum of 128 MB RAM and 4MB Video RAM for use with a 6.3 MegaPixel camera; more if you can afford it.**

# ......The Bottom Line

The storage requirements of JPEGs is much less, but there will still come a time when your workstation runs out of space. (See pages 134–7 for details on editing and disk management.) This will also affect applications like PhotoShop, which use spare hard-drive space as extra RAM. This is called a 'scratch disk', and it plays a major role in the speed of your system, so it pays to allocate enough space to one.

If you are ordering a new workstation, make sure that it has two internal hard drives. The primary drive, used for programs, data and so on, should be a minimum of 800GB, with the secondary drive around 20GB. This secondary drive can be allocated as the scratch disk and used solely for this

purpose, ensuring that the system is really fast. Also, drives now come in various speeds, from 5400rpm upwards. If you want the quickest system, it is worth paying the extra cash for the fastest. If not, 5400rpm will still suffice.

To modify an existing workstation, there are two options: partition the drive, or use an external hard drive. Disk partitioning allows you to form two smaller disks from your existing hard drive. But be warned: this is not a two-minute 'no-brainer', it is a complex job requiring a complete system back-up and reinstallation, and so is best planned well in advance. My advice is to steer clear of this option.

The second option – an external hard drive – is my recommendation because it gives many archive and back-up options. Of course, this assumes that you have a Firewire/USB connection on your workstation. If not, a more complex SCSI drive may be your only option. These drives are available in sizes up to 500GB, with speeds matching that of internal drives, and are simple to install. I have six external Firewire drives and connect them when needed, although most of the time they are stored away from the dust. (See pages 172–3 for more details on these drives and practical considerations for using them.)

**Fig 2.10**
**External hard drives offer a simple and flexible option for expanding your hard-disk space, as well as providing a good back-up and archiving solution (see pages 172–3).**

Have one dedicated disk as a scratch disk (minimum size 20GB) or get a separate external drive.

**......The Bottom Line**

## Peripheral Connections

The D-SLR and its associated hardware (external card readers, portable storage devices and so on) use one of two connection types to hook up to your workstation. The most common is USB (the latest is version 2.0), but perhaps the easiest to manage is Firewire (referred to as IEEE394). To take advantage of these connections you'll need the necessary boards on your workstation. Macs have had these connections for some years, but older PCs may not have a single USB. Ideally you want at least one of each, and further expansion can be achieved by using an external hub.

**You need at least one USB and one Firewire connection.**

# ......The Bottom Line

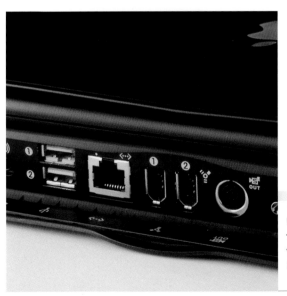

## Operating System

It doesn't really matter which operating system you use with a Mac, since all are designed to deal with graphics. I have heard multiple grumbles about OS X not looking the part, which is probably a reference to its similarity to Windows, but it does a great job with graphics. PC operating systems have a few more limitations, and I would say that Windows XP is the package of choice at the moment. It has some colour management built into the architecture and seems to be the most stable release since Windows 98. Be warned, however, that upgrading PC operating systems is a minefield and should be avoided if at all possible. Most PCs are designed to work with a single operating system as supplied, and any change voids the warranty and all support from the vendor (something I found out the hard way).

## Monitor

Often ignored, the monitor is a vital component of the editing process. Without a good, high-resolution monitor you will not be able to inspect your images in sufficient detail, and your colour management will be suspect. The industry-standard monitors for editing are based on Mitsubishi Diamondtron and Sony Trinitron architecture, and are designed for graphics. They come in a variety of sizes – 17in, 19in and 21in – but the larger versions are

**Fig 2.11**
**Peripheral connections are vital in order to connect the D-SLR and its associated hardware to your workstation. The most common connections are Firewire (second left) and USB (second right) ports.**

heavy and need solid support. I use a Lacie 22in ElectronBlue, which, though expensive, allows me to see very fine detail and make a judgement between two seemingly identical images. It also gives me extra USB ports (on the back of the monitor), which can be a bonus if you are lacking in that department. However, I am specialist, and most users should be able to make do with the monitor that was supplied with the workstation. Those who want to upgrade, or are buying a new system, should consider either a 17in tron monitor or a high-quality flat-screen LCD.

I touched on the issue of colour management in the text above. If you want to colour manage your system so that you can achieve consistent results on your printer and to allow distribution to other workstations, you will need to use either a software or hardware calibrator. These products require your monitor to be adjustable in terms of its brightness, contrast and individual red, green and blue colours. Without this you cannot calibrate effectively, and it pays to ensure that your chosen monitor can do this up front before you spend your hard-earned money on something that only does half the job. Don't worry if you already have a monitor that cannot do this, you'll just need to buy some extra printer paper and invest time in figuring out how your system behaves.

**Get at least a 17in monitor, ideally Diamondtron or Trinitron and with adjustable RGB settings if possible.**

## ......The Bottom Line

## CD

It is essential for back-up and image distribution that you have a CD burner. This is not really an issue with the latest workstations, as most have one included as standard. Check the speed of the write operation (usually quoted after the read speed). Ideally, the minimum should be 24x. With older workstations you may find that all you have is a CD-R (Read only). If you don't feel like buying a new system, you have some other options.

**Fig 2.12**
**If your workstation doesn't have its own CD-RW, an external CD drive is an essential.**

**Fig 2.13**
**CDs are ideal for image archiving and distribution, offering 700MB of storage.**

**A CD-RW with a write speed of 24x is essential.**

## ......The Bottom Line

External CD drives are now available from several companies, and can be connected either by Firewire, USB or SCSI. Either way, a CD-RW (Read/Write) is essential for any digital-imaging system. DVD burners are now emerging onto the market, and as DVDs offer 4.9GB of storage versus the CD maximum of 700MB, this may seem like a great idea at first. However, putting so many images on one device is asking for trouble. It's probably best to leave DVDs for their prime purpose: distributing your favourite movies.

### External Devices

I've already covered external Firewire hard drives, but another common consideration is a graphics tablet. These provide a position-sensitive pen (and sometimes a mouse), which allows you to be a lot more accurate with any digital manipulation. I use a combination of both, but prefer the mouse for most of the imaging that I perform.

## Archive and Catalogue

The first task that I perform in my workflow is to back up my RAW files to CD, and the last is to back up the finished TIFF files to CD too. Storing images on hard drive only is a risk. I have been caught out several times by a hard-drive failure and it takes a long time to recreate the files. The minimum requirement for a back-up strategy is a CD-RW, but other devices such as external hard drives and tape storage devices can play a part too. A back-up solution is pointless if you don't know where the back-ups are stored, and a visual database like Extensis Portfolio will help your management immensely. Not only does this help with back-up, but also with web and CD templates for sending out to clients, friends and so on. (A complete run down of all your options, plus some suggested management strategies and products can be found on pages 168–79.)

**Fig 2.14**
**A mouse (a Mac version is shown here) should be good enough for everyone, but if you need to tweak an image, a tablet is a useful friend.**

# Choosing RAW or JPEG

# Choosing RAW or JPEG: The Key Decision

I stand by my earlier claims: deciding whether to use RAW or JPEG as your storage format is the most important decision you will make when configuring your D-SLR. Most users I have spoken to about this issue are under the misapprehension that the difference between the two is simple – RAW is much better quality than JPEG. I was in this camp too, but now I'm sitting firmly on the fence. Both RAW and JPEG have their uses; the trick is knowing which to use at any given time.

Before we look in depth at the pros and cons of RAWs and JPEGs, the different workflows for the two approaches needs to be defined. A useful analogy is to think of the whole RAW versus JPEG question as washing the car. There are two ways do this: you can either do it yourself, or take it to an automated car wash. If you wash it yourself then you do so in a set pattern – first you wash, then rinse, dry, polish and finally wax. You don't wax before you wash and don't polish before you dry. Washing it yourself is a pride thing. You can pay fine attention to detail, take a perverse pleasure in scrubbing the flies from the windshield and produce a much higher quality result. If you get something wrong and don't do it well enough, it's easy enough to go back and redo it. The problem is that it takes time, and a lot of it.

For those of us without such time, the automated car wash is a much more appealing alternative. Once you put your money in the slot you can sit back as the brushes scratch and gnaw at your paintwork. In five minutes you have a relatively clean car. It's not perfect on close inspection, but good enough for what most people need. The problem is of course that once you've selected your program it is impossible to change it, and the only alternative is to go though the whole cycle again.

# The JPEG Workflow

Think of the JPEG workflow as the automated car wash. It is quick, requires minimum effort, and produces good results. The JPEG itself can be thought of as a digital slide – once you press the shutter button, the image is 'developed' and ready to be used straight away. The elements of a JPEG workflow are shown opposite.

The D-SLR processing is as follows. The RAW image data is acquired from the sensor and loaded into the buffer, along with user-specified shooting parameters. These parameters can be customized via the LCD menus and allow you to specify values for sharpness, contrast, saturation and white balance (among others) on a per-shot basis. (See chapter 4, pages 70–93, for details on setting up your D-SLR.)

If JPEG is the required format, these shooting parameters are applied to the RAW image data, which is then compressed into

JPEG format. Finally, the JPEG is written out to the storage card, and at this point it is finished and ready for use. It can be loaded into PhotoShop for slight tweaking, or immediately printed, emailed and/or burnt to CD. I know several pros who simply download their JPEGs straight to a CD burner and hand the finished CD to the client – no processing, no hanging around at labs, no scanning. As a home user, you can print your pictures immediately, like having your own mini developing lab at home without the smelly chemicals. It's just the same as the automated car wash – no hanging around or

hard physical graft. The problem, however, is that the shooting parameters, once applied in the D-SLR buffer, cannot be changed. Although an image can be rescued in PhotoShop there is a limit to what can be done, and if you get the shooting parameters wrong you will therefore have to start the whole picture-taking process again.

This approach, despite its drawbacks, appeals to many film users as it mirrors what they do now. Once you press the shutter you have the final image. The only difference is that a D-SLR can help you get the shot right before you press that button.

# The RAW Workflow

The RAW workflow (below) can be thought of as the manual car wash. It takes longer, but is more flexible and the result is generally better.

The image data is loaded into the buffer as before, along with the shooting parameters.

This time, however, unlike the JPEG workflow, the image data is not processed or 'developed' any further. The shooting parameters are not applied and are shipped out to digital film along with the image data. The difference at this stage between a 'developed' JPEG and a RAW file can be illustrated graphically (opposite).

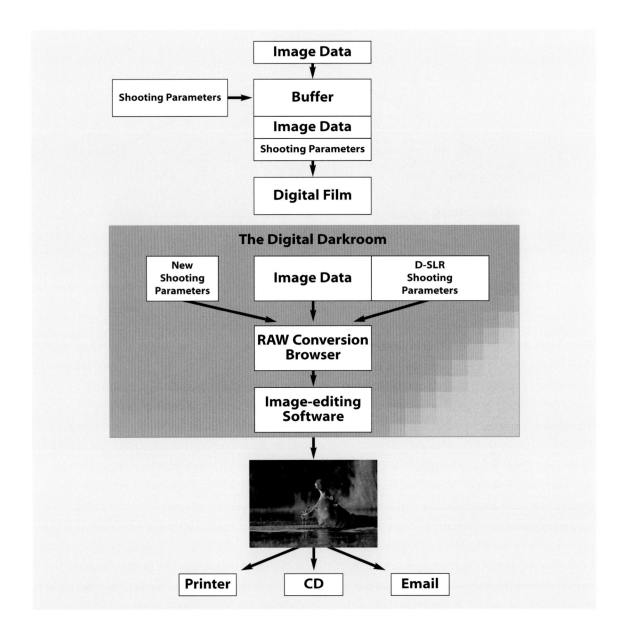

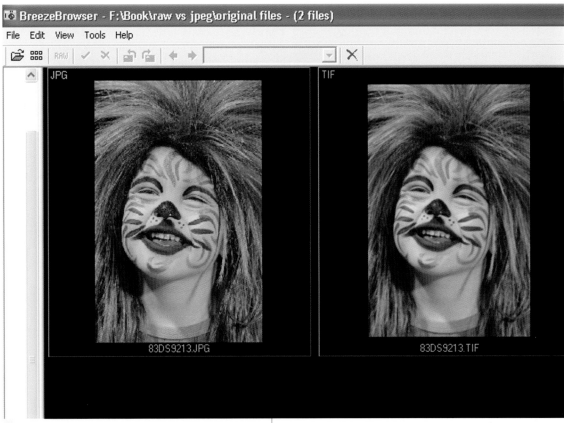

**Fig 3.1**
**A direct comparison between a 'developed'**
**JPEG (left) and an 'undeveloped' RAW (right).**

The JPEG on the left looks much sharper than the RAW on the right, but both of the images shown above have the same shooting parameters and levels of sharpness. The difference is that they have already been applied to the JPEG at the D-SLR stage – it is a finished image. The shooting parameters for the RAW image are attached to it, but only applied at the browser stage. If you don't like the parameters that you have taken the shot with, they can be discarded and new ones used (except for ISO and exposure). This is the major 'architectural' difference between RAW and JPEG.

# The Pros and Cons

Clearly there are differences between RAW and JPEG, but which is the best? The answer is that they are equally useful, although that probably sounds a little unhelpful. To demonstrate the pros and cons effectively it is necessary to look at all the issues surrounding their usage.

## Quality

Since a RAW image is pure data, while a JPEG has been compressed, it would be natural to assume that the former provides better final

Fig 3.2
The images become easier to compare when shot using the RAW + JPEG option. However, there is little visible difference between the RAW TIFF (left) and the JPEG (below) at this magnification, even though the JPEG is a compressed file.

image quality. The only way to verify this is to test it, which I did by using the RAW + JPEG option of my EOS 1DS. Using the face-painting image shown previously, I converted the RAW file into an RGB TIFF file using the same shooting parameters as had been applied to the JPEG. For those of you wondering what an RGB TIFF is, just consider it as the 'developed' form of a RAW file. At 100% magnification they both look identical (Fig 3.2), so clearly a much higher magnification is needed (Fig 3.3).

The keen-eyed among you will see that there is surprisingly little difference between the JPEG and the TIFF versions, even at this

enormous magnification. It follows that if you printed these two at the same print size, you'd notice little difference. There is a very big difference, however, in the file size. The TIFF image is a whopping 32MB at 300dpi, while the JPEG is just over 5MB. That is a 600% reduction in size without apparent loss in quality.

**Fig 3.3**
Even when viewed in extreme detail, some differences become apparent between the two formats. However, the fractional drop in quality experienced with the JPEG belies its much smaller file size (5MB, compared to a massive 32MB for the RAW TIFF).

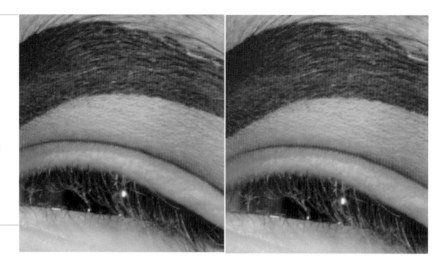

TIFF                    JPEG

The compression capabilities of a JPEG have long been known, but all too often these have been associated with a marked drop-off in image quality. Modern JPEG algorithms, however, such as can be found in the latest D-SLRs, use highly efficient techniques. At their finest quality they can be considered as virtually 'lossless' in terms of quality, although a tiny proportion of image data is still lost.

The key is how much our eyes are able to resolve this loss – we all know the maths, but does it really count in the real world? Perhaps it would be truer to describe JPEG compression as 'visually lossless' at the best-quality settings.

The main problem with JPEGs is that they cannot be edited and continually re-saved without an appreciable loss in data.

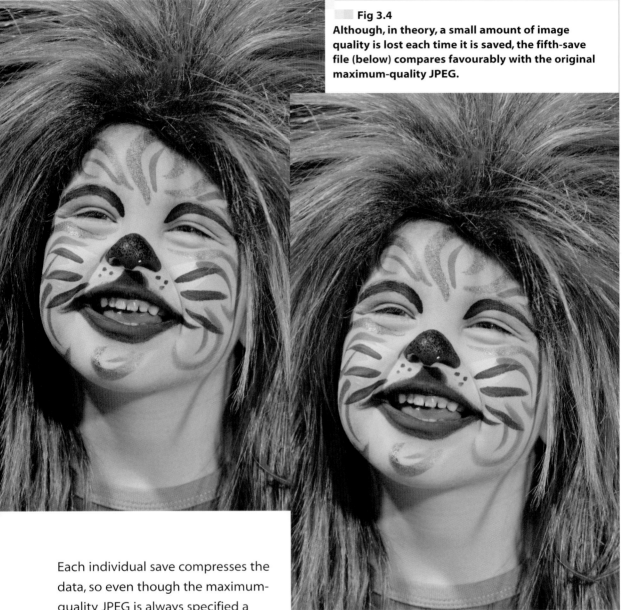

**Fig 3.4**
**Although, in theory, a small amount of image quality is lost each time it is saved, the fifth-save file (below) compares favourably with the original maximum-quality JPEG.**

Each individual save compresses the data, so even though the maximum-quality JPEG is always specified a small part of the image is lost each time. For the following test I saved the same JPEG file five times, each time using the highest quality setting (12 in PhotoShop). It provides some interesting results, as shown above.

The difference between the fifth-save file and the first is noticeable, but perhaps not as much as would be expected. From a maths point of view these images are substantially different, but visually they are virtually identical. Admittedly, if I had carried out extended processing between each save, the differences would become more apparent. However, the question remains

**In terms of visual change there seems to be little difference between a 32MB TIFF and a 5MB JPEG that has been saved several times. If all you are doing is printing up to A4 (as most of us do), no one will be able to tell the difference between the two.**

## ......The Bottom Line

how much we can perceive the changes visually. Of course, if you intend to do some extended processing on your JPEG image then you can save it as a lossless RGB TIFF. This can be done either at the browser or PhotoShop stage; either way it will allow you to do recursive saves without a loss in quality. This approach will be demonstrated in more detail in chapter 7 (see page 142). The downside is still that you are lumbered with an original 'out of the camera' developed image, without much flexibility for change other than by spending time at your workstation.

## Flexibility

By now it should be apparent that the question of a difference in quality between RAW files and JPEGs is not so clear-cut. One issue that is without question, however, is that a RAW image allows a lot more flexibility at the 'developing' stage. If you get the exposure or white balance wrong with a JPEG, you can do little to change it. Of course, you could use an image-editing tool like

PhotoShop to make adjustments, but this is time consuming and may not always produce great results. RAW images suffer from few of these limitations: as the shooting data is not applied to the RAW image data, it can be changed at the browser stage of the workflow. For example, if the image is slightly too dark, it can be brightened using the 'undeveloped' raw image data rather than the 'developed' image data.

Personally, in my field of wildlife photography I am constantly dealing with the vagaries of light conditions and different shades of fur, which play havoc with my metering. I shoot RAW by default and develop the files at the browser stage, which allows me to have maximum control of my images. The downside is that I currently have a stack of over 2000 RAW images waiting to be processed, and if they are stuck on my PC they aren't earning me money. I know a lot of fellow pros who also shoot RAW to allow maximum flexibility, but all of us suffer from the backlog that this can create. There are some tricks to speed up the RAW editing process and they will also be outlined in chapter 7 (see page 147).

## Noise

Signal noise from an imaging sensor is more apparent with a JPEG than a RAW image due to the compression. In fact, there is no doubt that with long-exposure or low-contrast photography, RAW images do exhibit less signal noise than JPEG images. Whether this is detectable in every situation to the human eye is less certain, but for now I'll assume that it is.

▪ **Fig 3.5**
An atmospheric shot of a proud male lion in the Masai Mara, which has been deliberately underexposed to create the effect. Moody images like this can often be prone to some signal noise (see page 86) in the darkest areas, but with careful processing in the digital darkroom its effect can be removed. (See chapter 7, pages 125–165, for more information on workstation processing.)

If you are shooting long exposures (perhaps at night or inside a building), a RAW image will probably be your preferred choice. With this kind of landscape image it is extremely difficult to get the exposure exactly right, so some later processing will usually be necessary, reinforcing the need to use RAW.

## ......The Bottom Line

# Dynamic Range

RAW images, since they are formed directly from the sensor, have 12 bits/channel of data. JPEG images, due to the processing and compression within the D-SLR, are output at 8 bits/channel. A 12-bit image should have a greater range of colours than an 8-bit image, giving more scope to make changes. This means that a RAW should be dynamically superior to a JPEG, and having more bits available also allows greater latitude for subtle changes of colour.

Human eyes suffer from many limitations, and one of these is in their limited ability to perceive colour at the higher and lower ends of the spectrum. The 12 bits of colour contained in a RAW image may not actually be perceived as 12 bits at all, but slightly less. Couple this with the fact that to be displayed these 12 bits have to be converted to 8 bits anyway, and the differences are virtually impossible for the human eye to detect.

# Performance and Storage Considerations

Any professional sports photographer worthy of the name will shoot JPEG. They do this for two reasons: image size and performance. With a Canon 1D you get 96 RAW images to a 512MB CF card, yet you can get 196 FINE-quality JPEG images on the same card. This means having to change cards less often, which reduces the chance of missing a great shot.

In terms of performance, consider the following test I carried out on the EOS 10D.

I shot continuously until the buffer was full, then recorded the time that it took for the next shot to become available. For a RAW this was approximately 1.7 seconds, for a JPEG-FINE it was closer to one second. To write all the buffered RAW images to the storage card took nearly 40 seconds, while for the JPEG-FINE it took just over 12 seconds. Clearly, with JPEG-FINE the chance of lockout is drastically reduced, allowing more continuous action to be recorded. If action is your bag, JPEG-FINE should be the chosen format for this reason alone.

One last point on the performance issue: battery usage. Using JPEG gives a much greater number of shots per battery charge, as the D-SLR processing is less than for a RAW image. This may become an issue if you are on holiday and don't have access to a regular power supply to recharge your batteries. The issues of battery usage and travel requirements will be covered on page 119.

# Software Advances

RAW conversion software is being improved all the time, which in turn can improve the quality of the developed RAW file. For example, a Nikon RAW (a NEF in their terminology) taken on the D1 camera will yield a better result when converted with version three of the Nikon Capture software than version one. This means that you should always have the option of improving your final quality by using an updated browser, provided that the manufacturers do not change the format. With a JPEG, you have no such option because it's already developed.

# Summary

Clearly there is not as much difference between a RAW and a JPEG file as might at first be thought. In fact, the main reason for shooting one or the other boils down to the time factor. The JPEG workflow, provided that you get everything more or less correct, has by far the quickest shoot-to-print time. Using the Polaroid-style exposure features unique to a D-SLR, you can ensure that your JPEGs are close to the correct exposure. If you don't care about shoot-to-print time, want to have the ultimate in flexibility, and enjoy manipulating images on your workstation, RAW is the better option.

A summary of the main points in this chapter:

- If you aren't printing above A4, there will be little difference visually between RAW and JPEG-FINE.
- Although RAW offers the advantage of flexibility, it introduces post-processing time and reduces in-camera performance.
- Although JPEG has the shortest shoot-to-print time, it is a fully developed image and offers little room for manoeuvre outside of PhotoShop.
- Landscape or creative photographers who use exposures of greater than one second should use RAW to minimize noise issues and allow greater exposure flexibility at the developing stage.

- For high-action, news or PR photography, where throughput is often the requirement, JPEG should be the format of choice.
- For landscape and wildlife professionals, where clients demand ultimate image control (and in some cases are reluctant to move away from film), there is no choice but to shoot RAW.
- For the majority of D-SLR users, JPEG-FINE is the obvious choice. Provided that you adhere to the exposure guidelines, your images will be perfect for your needs, whether that means entering camera-club competitions, print images to a reasonable size, or sending work to a camera magazine for publication (see pages 176–9 for hints on distributing your images).

Some extra tips for those shooting JPEGs:

- Shoot only JPEG-FINE, and set at the largest resolution.
- If you are going to print your image straight away, keep it in the JPEG format. If you need to save it once, do so at the maximum quality.
- If you are going to manipulate your image, save it first as a 'lossless' TIFF. Once you have finished all your manipulation, save it as a JPEG Maximum Quality. Chapter 7 (see page 125) will cover this in further detail.

## Pro Tip

There will be occasions when you need a RAW – perhaps when you're faced with a difficult lighting condition or if you plan to do a lot of image manipulation. A good solution is to use the RAW + JPEG option, which is available on the latest range of D-SLRs. This allows the D-SLR to shoot RAW and JPEG images simultaneously, which are then written to the storage card. The JPEG has its shooting parameters applied, while the RAW has its attached but unapplied. If you find that the RAW is not what you want but you still need the image, you can keep the JPEG (and vice versa). Make sure that you set the JPEG option to its maximum quality, otherwise you might accidentally get a thumbnail. The three issues to be aware of with this option are the decreased number of images on a storage card (approx. 25% less), reduced buffer size, and increased write time. Still, it's a useful option to have. I know some pros who shoot RAW + JPEG purely so that they can use the performance advantages of the JPEG at the editing stage.

**Fig 3.6**
To get this shot I had to lie underneath my vehicle, balance the lens on a beanbag and carefully place one of my focusing points directly between the cheetah's eyes.

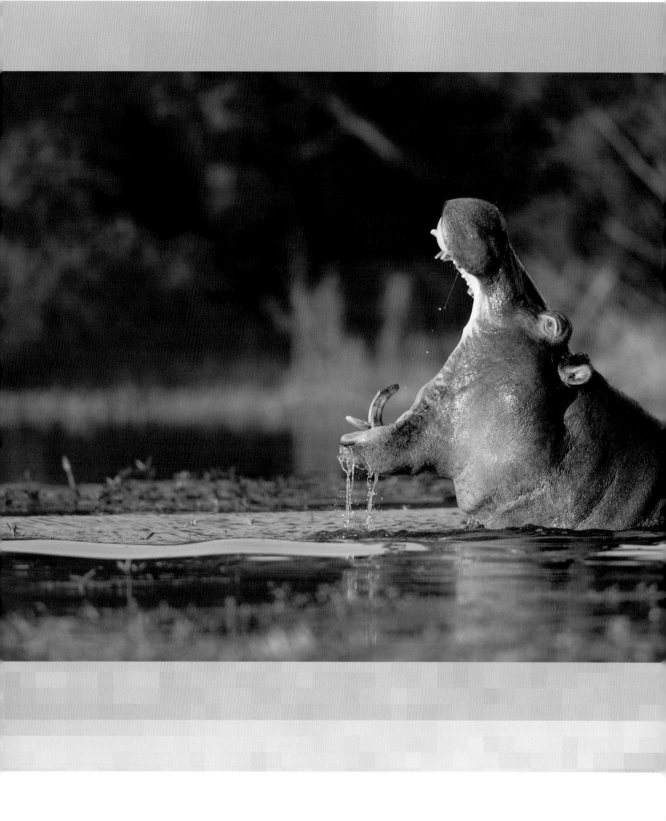

# Setting Up Your D-SLR

# Setting Up Your D-SLR

Having covered the complex technical theory behind digital capture in the previous chapters, it is now time to look at how to set up the D-SLR ready for use in the field.

By now the concept of shooting parameters in a D-SLR should be pretty well defined. In the previous chapter, most of the arguments for the use of RAW files were based on the assumption that user-specified shooting parameters could be changed at a later stage. These shooting parameters come in several guises depending on which manufacturer's D-SLR you have; 'processing parameters' and 'user parameters' are just some of the names. For the sake of simplicity, the term 'shooting parameters' will be used from now on.

The first fact to be aware of is that different manufacturers have different philosophies concerning shooting parameters, and you should check the default settings in your manual. Nikon took a hands-off approach with the D100, and by default most of the shooting parameters are initially switched off. This means that no sharpening is applied to JPEGs, and they may appear a little on the soft side. Canon, on the other hand, applied 'standard' values to their default setting, and as a result their default images look sharper out of the camera.

The idea of this chapter is to acquaint you with all the basic user parameters and their effect on an image. This is particularly important for JPEG shooters, as some parameters are irreversible. RAW shooters might argue they do not matter at all because they can be changed at the browser stage. While this is true for most of the parameters (except the ISO rating and certain exposure settings), it is surely better to get things right at the picture-taking stage rather than spending hours in front of your workstation.

The following are the most common parameters that you will find buried in your D-SLR menus:

- Image Quality
- Colour Temperature (on later models only)
- White Balance
- Colour Processing Parameters
- Colour Space/Colour Matrix
- Colour Mode
- Sharpening
- ISO and Noise Reduction
- File Numbering

# Image Quality

Although the previous chapter covered the issues of choosing RAW or JPEG, there are still a few more decisions to make with this parameter. Consider this data (above opposite), which shows the options listed in a well-known D-SLR's manual (although similar tables can be found in all D-SLR manuals).

| | Format | Approx. file size | No. of images |
|---|---|---|---|
| **RAW** | **NEF (uncompressed)** | 9.4MB | 54 |
| | **NEF (compressed)** | 5MB | 102 |
| **RGB-TIFF** | **Large (3008 x 2000)** | 17.3MB | 29 |
| | **Medium (2240 x 1488)** | 9.5MB | 53 |
| | **Small (1504 x 1000)** | 4.3 MB | 119 |
| **JPEG-FINE** | **Large (3008 x 2000)** | 2.9 MB | 176 |
| | **Medium (2240 x 1488)** | 1.6 MB | 320 |
| | **Small (1504 x 1000)** | 770 KB | 664 |
| **JPEG-NORMAL** | **Large (3008 x 2000)** | 1.5 MB | 341 |
| | **Medium (2240 x 1488)** | 850 KB | 602 |
| | **Small (1504 x 1000)** | 410 KB | 1248 |
| **JPEG-BASIC** | **Large (3008 x 2000)** | 770 KB | 664 |
| | **Medium (2240 x 1488)** | 440 KB | 1163 |
| | **Small (1504 x 1000)** | 220 KB | 2327 |

If this seems like information overload, it is because there are just too many options available, most of which have no application or place in anyone's photography. The headings below take a detailed look at the more relevant options.

## RAW

Most D-SLRs just provide a single option for RAW, although they masquerade under a number of different names (RAW, CCD-RAW and NEF, for example). Nikon, however, allow you two RAW options: compressed NEF and non-compressed NEF. The initial assumption may be that compression means quality loss, but as mentioned in chapter 3, this depends on how much visual loss is noticeable (see page 61). The compressed NEF relies on the fact the human eye can't visualize all the colours in a 12-bit uncompressed NEF, and effectively throws this 'blind' data away to achieve compression. (Check out the excellent D100 & D1 Generation eBook for more details.) My policy on shooting RAW is to select the maximum (uncompressed) size to capture the maximum amount of information. The file can always be cut down to size later, but you can't replace what you don't have in the first place.

## RGB-TIFF

RGB-TIFF is essentially the same as JPEG-FINE (i.e. a fully developed image). The only difference is that the TIFF is 'lossless'. This means that if you want to generate a lossless file for manipulation in PhotoShop, without any chance of pre-processing at the development stage (the browser) first, RGB-TIFF is the option for you. Of course, being lossless it can be tweaked in PhotoShop, but it is always better to tweak raw image data than developed image data. This, coupled with a card-splitting file size of 17.3MB, makes RGB-TIFF a non-starter for most photographers.

## JPEG Workflow

How many JPEG options are there? How many do we need? The only JPEG options that are necessary are JPEG-FINE and JPEG-BASIC. The former is used for standard JPEG workflow processing and produces the highest-quality output. The latter will be used by professionals in conjunction with the RAW + JPEG option to generate tiny 'approval' thumbnails while working in the field. If you are shooting JPEG, my advice is to stick to JPEG-FINE.

# Colour Temperature

All sources of light contain varying amounts of the three primary colours: red, green and blue. The human eye perceives all colour sources to be normal – i.e. we don't see the different proportions of the primary colours in a certain light source. Can you tell, for example, that a light bulb emits more red light than blue? No, because our eyes are marvellous tools that correct everything to look white. The colour of a light source is measured in units of degrees Kelvin (°K), and this is referred to as its 'colour temperature'. The lower the colour temperature, the more red is contained in the light. Conversely, at the other end of the scale, higher colour temperatures radiate a higher proportion of blue light.

Photographers refer to images with a higher colour temperature as appearing 'cooler', and images with a lower colour temperature are said to be 'warmer'. Unfortunately, the camera is not good at adapting to different light sources, particularly artificial lighting. For example, using a daylight-balanced film (5500°K) indoors with tungsten lights will give an orange cast. This is because the tungsten lights have a colour temperature of around 3000°K, which is at the red end of the colour-temperature spectrum. To correct this and make the light source correspond to white (i.e. 5500°K) we need to add blue – hence the use of a blue correcting filter with film cameras. The result is a balanced scene that matches what your eye sees.

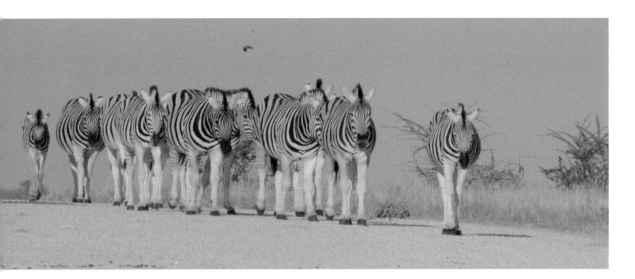

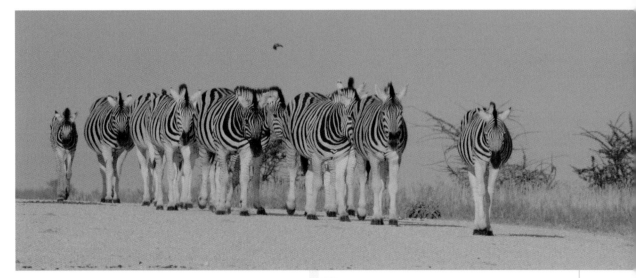

**Fig 4.1**
**The top image has a blue appearance as the camera's WB was set to TUNGSTEN, but this can be corrected in the browser (bottom).**

Fortunately, the D-SLR provides several preset 'software filters' that allow you to cater for this very situation. This is referred to as the 'white balance' (WB). To put it simply, with a quick adjustment you can now shoot confidently in any lighting situation and get a resulting image that looks 'normal' to your eyes. If you want to be creative, you can use the wrong white balance for any given situation, as shown above.

The images above show the effect of setting the WB incorrectly for the ambient lighting. With the camera set to Tungsten, the image takes on a much bluer appearance (top). Correction in my browser gave the more accurate image (bottom), but the arty side of me likes the original.

# White Balance

White Balance is a shooting parameter, and so the user must set it to an initial value. I say initial because as the light changes you can adjust the white balance accordingly to compensate, perhaps from sunny to cloudy. Most D-SLRs have the same subset of white balance settings, and those for the EOS 10D are shown in the table below.

For most conditions it is pretty easy to select a WB that suits. Problems usually only occur indoors with different types of lights. Fortunately there are some options to help with this (see page 78–9).

## Auto White Balance (AWB)

If you are shooting RAW you can easily set the WB parameter to AUTO (or AWB). If the white balance is incorrect, you then have the option of changing it at the browser stage. When shooting JPEGs, it is vital that you assess the light conditions and set the correct white balance. Using AWB might seem the easy option, but there are many cases where AUTO is not the best choice and may give you misleading results. Again, the penalty for not getting it right when the shot is taken is time spent in front of the workstation making corrections.

| Symbol | Title and Description | Colour Temperature (°K) |
|---|---|---|
| AWB | Auto White Balance | 3000–7000 |
| | Daylight Sunny | 5200 |
| | Daylight Shade | 7000 |
| | Daylight Cloudy or Hazy | 6000 |
| WB | Flash | 6000 |
| | Indoor Fluorescent Light | 4000 |
| | Indoor Tungsten Light Bulbs | 3200 |
| K | Colour Temperature | 2800–10,000 |
| | Custom White Balance | 2000–10,000 |

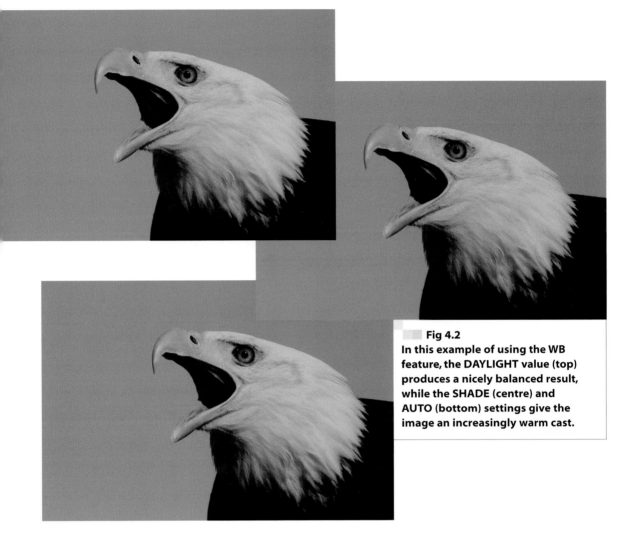

Fig 4.2
In this example of using the WB feature, the DAYLIGHT value (top) produces a nicely balanced result, while the SHADE (centre) and AUTO (bottom) settings give the image an increasingly warm cast.

# A Guide to Using White Balance

Perhaps the best way to show the effect of WB is to walk through several examples.

## Example 1

Our first example shows Liberty, a bald eagle, shot in perfect late afternoon light at three different WB settings. The DAYLIGHT WB value shows a nice blue sky and perfectly balanced colour on Liberty's feathers. WB SHADE in this case shows a much warmer cast, with WB AUTO warmer still. From the table opposite, we can see that the colour-temperature setting for WB SHADE is 7000°K, which is much cooler than the actual light source (the sun) at 5500°K. With the WB set to record at 7000°K, the end result looks like an 81a warm-up filter has been placed over the lens. It's not a displeasing result; in fact, I prefer it from AWB setting, which is too warm, and the WB DAYLIGHT setting, which is slightly too cool. It's a personal preference and I know that my agent much preferred the WB DAYLIGHT results with the blue sky.

**Fig 4.3**
**WB settings: DAYLIGHT (left),**
**AUTO (below), CLOUDY(below**
**left) and SHADE (bottom).**

## Example 2

A wildebeest is about to have a very bad day!
This time the sun was low on the horizon
and you can see that WB DAYLIGHT and
WB AUTO gave the image the same 'cool'
feel (around 4500°K). The problem is that
the image was far from cool; the light was
red and really beautiful. Setting WB to
CLOUDY (6000°K) gives a much warmer
image, but changing this to WB SHADE
(7000°K) gives the most representative result.
Again, WB AUTO was not the best choice.

## Example 3

This shot of a blackbird was taken under cloudy skies. WB AUTO has again picked a cooler image, with a slightly blue tinge. Cloudy light has a colour temperature of approximately 6000°K and WB CLOUDY appears to hit this dead on, as you would expect. The colours are as I remember, with a nicely saturated green and good colour on the subject. WB SHADE (7000°K) is predictably warmer, as if an 81a filter has again been used. Personal choice? Well, I shot it on WB CLOUDY and on this occasion I prefer this to WB SHADE. Again, WB AUTO gave the worst result of the three in my opinion.

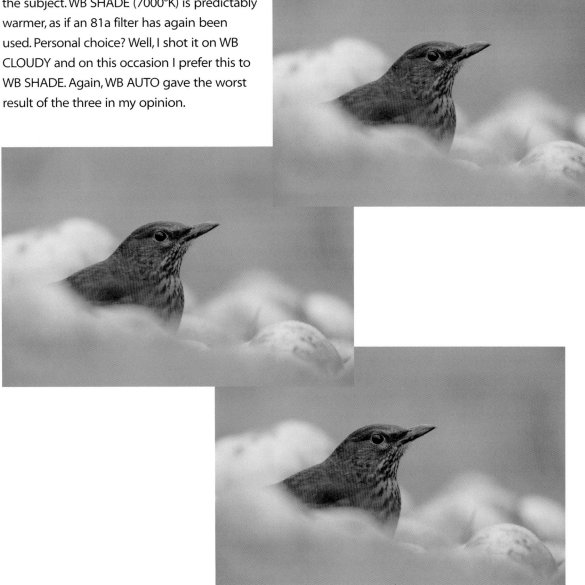

**Fig 4.4**
**WB settings: AUTO (below), CLOUDY (below left) and SHADE (bottom). As the conditions were overcast, WB CLOUDY gives the most accurate results.**

**Fig 4.5**
The combination of various forms of artificial lighting, plus diffused daylight, created an awkward exposure in which the digital camera's ability to alter the WB setting really comes into its own. The settings used are (clockwise from the top right): AUTO, DAYLIGHT, FLUORESCENT and TUNGSTEN. Of these, FLUORESCENT gives the most balanced result. By shooting RAW, it is only necessary to take one picture – the different WB settings can then be experimented with at the browser stage.

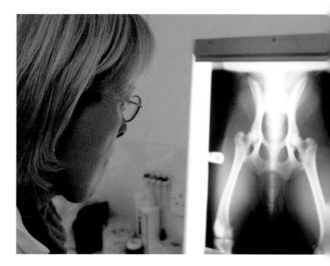

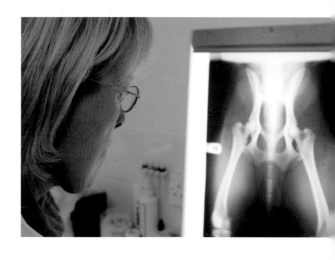

## Example 4

When shooting indoors, the ability to change WB really comes into its own, as shown in these four versions of the same image. This was shot taken for a magazine story on my local vet, Juliet Hayward. To give a more natural feel to the shoot I decided not to use flash, but the mixture of different light sources, which included diffused daylight, created a problem. To solve this, I decided to shoot the lot on WB AUTO and select the best WB at the browser stage. With the WB

set to DAYLIGHT the cast is slightly orange, but with WB TUNGSTEN it is far too blue. This suggests that the correct WB is closer to 5200°K than 3200°K, and means that WB FLUORESCENT (4000°K) gave the most balanced results.

Remember: those of you shooting RAW have the luxury of changing WB at the browser stage, as I have done in these examples. Some browsers, like CaptureOne, also allow you to pick a custom white balance point from the image, which saves time (see page 81).

For those of you shooting JPEG, I have hopefully shown that WB AUTO is not always the best setting to use. In fact, in my experience WB SHADE gives much more pleasing results and the 'warmer' image that most of us like. If you're in an artificially lit situation like the one shown in Example 4, I would wholeheartedly recommend choosing a RAW format as it is more forgiving of errors.

## Filters and WB

Photographers use coloured filters to create a specific effect. Unfortunately, using an AUTO WB will often reduce these effects or cancel them out completely. If you are using filters, it is best to set the WB to DAYLIGHT for correct results. Of course, many photographers these days use tools like PhotoShop to apply filter effects to their images and have dispensed with real filters completely. However, there is something that I like about the feel of slotting filters in a holder, experimenting with them and actually creating a shot in the field.

### Flash and WB

**Just a few words here on using flash with your D-SLR. The flash colour temperature for most D-SLRs is slightly cooler than Cloudy WB. If you are using flash in daylight for fill-in purposes, you can effectively ignore its effect and base your WB on the external light conditions. When using flash indoors, however, it's best to use the supplied Flash WB, although I have had very good results when using AUTO WB with flash.**

## Fine-tuning the White Balance

If you ever need a more precise WB value, most D-SLRs come with several parameters to fine-tune the WB:

- Colour Temperature
- WB Fine Adjustment
- Custom/Personal White Balance
- White Balance Bracketing

### Colour Temperature
The most recent D-SLRs now have a colour-temperature (CT) parameter in addition to the WB, and this often causes some considerable confusion. The CT option and WB shooting parameters are mutually exclusive – you either use one or the other even though the menus seem to suggest that you use both at the same time.

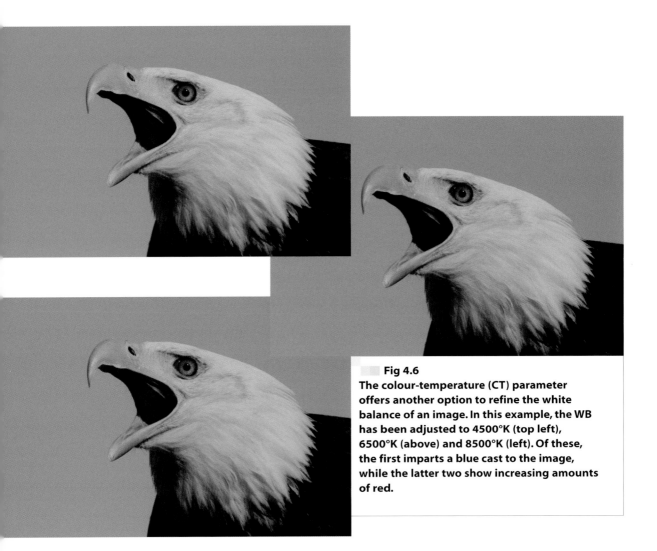

**Fig 4.6**
The colour-temperature (CT) parameter offers another option to refine the white balance of an image. In this example, the WB has been adjusted to 4500°K (top left), 6500°K (above) and 8500°K (left). Of these, the first imparts a blue cast to the image, while the latter two show increasing amounts of red.

The idea of the CT parameter is to allow you to dial in a much more accurate colour temperature for the white balance. I know several professionals who have contracts in various theatres in London's West End. Each theatre has specific lighting requirements, but once a show is set up it doesn't change for years. So, at the start of the show's run, one of the pros goes along with a CT meter and measures the exact colour temperature at the venue. This information is then shared among the group of photographers,

**The colour-temperature parameter is best left to those who really need it. For the rest, the standard WB settings are perfectly good enough as a starting point.**

## ......The Bottom Line

who use the CT parameter to enter it into their cameras.

To show how colour temperature can be used to change the overall balance of an image, I have re-used the image used in Example 1 (see page 75). As you can clearly see from the images shown opposite, the lower, warmer colour temperature of 4500°K gives a blue cast to the image. While this certainly deepens the blue saturation of the sky, the problem with this approach is that it gives a blue cast to everything. The 6500°K and 8500°K images show increasing amounts of reddish cast, as you'd expect. Sometimes I do use this parameter but only at the RAW conversion stage in a browser to fine-tune the supplied WB settings.

### WB Fine Adjustment

Some D-SLRs, like the Nikon D100, allow you to fine-tune the preset WB colour temperature by varying increments. This allows for minute variations in different light sources and is really for perfectionists. By far the most accurate readings in these situations are given by a colour-temperature meter, and not by fiddling with these parameters. My advice is to leave well alone unless you desperately need it.

### Custom/Personal White Balance

There is a simpler way of adjusting the WB than carrying around a fragile colour-temperature meter. The terminology varies from one D-SLR to another, but most allow you to set a WB from either a stored image or a scene through the viewfinder. The most common approach is to hold up a white card in front of the camera, which sets the WB to

correspond to white light. Again, this is a nice feature to have, but its application will be limited for most D-SLR users. If you are shooting the RAW workflow, most browsers will allow you to select a white-balance point from an image by using an eyedropper tool. I have used this approach only a handful of times, but each time it was a necessary step to save the image.

### White-balance Bracketing

Several D-SLRs now provide a bracketing option for WB, which takes three consecutive exposures at different WB settings. This will be of limited use to anyone shooting RAWs as the WB can be altered at the browser stage. However, if you are shooting JPEGs it might not be such a bad idea (in the same way that bracketing film exposures can help to make sure that you have at least one correctly exposed image).

## WB sensors: In-camera versus External

D-SLRs usually have a WB sensor that takes its data through the lens (TTL), measuring the light that falls on the imaging sensor. Some new D-SLRs, however, have an external WB sensor, which is mounted on the front of the D-SLR body. This provides a more accurate reading of the WB, but if obscured it can give a misleading reading. I first found this out while shooting grey herons from inside a hide, and wondered why all the RAWs I took were slightly off when viewed on my browser. The darkness inside the hide had confused the sensor and affected its ability to measure the WB of the scene outside.

# Colour-processing Parameters

Various D-SLRs allow you to set different
colour-processing parameters such as hue,
saturation and contrast. When shooting
RAWs, these should be set at 'standard', and
it's probably a safe bet to do the same with
JPEGs. When you change the contrast of an
image there is a fine line between a good
result and a result that degrades an image's
quality. This is easy to judge on a monitor, but
not so easy on a D-SLR's LCD screen. Perhaps
the most useful of these functions is the
saturation function, which has applications
across all areas of photography. Shooting at
a high saturation will definitely improve the
'punch' of the image, although some
subtleties may be lost in landscapes.

**Fig 4.7**
**A revealing comparison of the different ICC
colour space/matrix settings available on
most D-SLRs, and their effect in print: Adobe
1998 (right), sRGB Portrait (centre) and sRGB
High Chroma (far right).**

# Colour Space/Matrix

The problem of colour management has been
with us for a long time. How many times have
you printed an image on your home printer
and wondered why it is so different to what
you see on the screen? The answer lies with
colour profiles, or ICC (International Colour
Convention) profiles to be more exact.

An ICC profile is a universally recognized
measure of colour standards. They are
platform independent, which means that an
image with any given ICC profile should look
the same anywhere in the world (as long as

the monitor is colour-calibrated). An ICC profile is vital to photographers as it allows us to share images between a multitude of devices and, hopefully, maintain the intended colour. The profile can be thought of as a limpet; once saved it attaches itself to your image and follows it wherever it may go.

Although there are literally pages of ICC profiles, the D-SLR industry has picked two as standard: Adobe 1998 and sRGB. Adobe 1998 has been accepted worldwide as the standard ICC profile for proofing images before they are used in the media. Most books recommend its use, and if you are submitting digital files to magazines they will certainly require Adobe 1998 to be attached as the default profile. This is

mainly because of its large colour range, which allows more latitude during the printing process, as well as allowing a smoother transition between colours when manipulating an image in packages like PhotoShop. sRGB has a smaller colour range than Adobe 1998, and as a result it is rarely used for any media applications. One exception is the Internet, where sRGB is the recommended profile because of the relatively limited range of colours available on the web.

Most D-SLRs allow you to specify whether you would like Adobe 1998 or sRGB as your colour matrix/space. In addition, several provide additional options, usually varying degrees of sRGB saturation. The images opposite and below show some variations.

The image with the Adobe 1998 profile (Fig 4.7) has the widest colour range and therefore the most accurate colour – mathematically, at least. To me, the sRGB options look much punchier and more marketable, even though they have fewer colours. The sRGB High Chroma (Fig 4.7) version is perhaps a little over the top. It has very similar in output to Fuji Velvia, although the latter has a much greater range of colours. Aesthetically, sRGB clearly has a lot more to offer than at first thought, and there is an even more compelling technical reason to consider it: most (if not all) sensors in D-SLRs are effectively sRGB. This means that they capture the colour range equivalent to sRGB and not Adobe 1998. Therefore, if you select Adobe 1998 the D-SLR processes the sRGB colour data internally to give Adobe 1998 colour data. This is standard in the graphics industry, and PhotoShop carries out the same profile conversion when you load images into it.

So what does this all mean? Well, it depends entirely on the intended destination of your pictures. If you are just taking pictures for prints, setting sRGB as your colour space/matrix is as good an option as Adobe 1998. Since most PCs are sRGB based, and most printers default profiles are sRGB based

**sRGB may offer a better option than Adobe 1998, depending on the final destination of your work. Whichever you choose, make any conversions at the workstation stage and not within the D-SLR.**

## ......The Bottom Line

too, using this method will get you reasonable printed results without the hassle of profiling. Moreover, a little experimentation never hurt anyone and you might find that you actually prefer sRGB. However, if you're reproducing in the commercial sector you have little choice, as the standard is Adobe 1998.

# Sharpening

D-SLRs usually provide a sharpening parameter, which controls the level of sharpness attributed to the image when it leaves the camera. All D-SLR images need to be sharpened to some degree, but this parameter must be applied correctly. It is important to realize that it can only make a good photograph better; it cannot make an out-of-focus image sharp.

## *Colour Mode*

**Some D-SLRs allow you to select whether your image is taken in colour or black and white. This might initially seem like a great way to get black-and-white pictures, but in reality it is a trap for the unwary. Taking a picture in black and white is an irreversible process – once captured, you are stuck with that image data. Converting an image to monochrome in an image editor like PhotoShop at the digital-darkroom stage will give you more control over the finished product, and it will look better as a result.**

**Fig 4.8 and close-up**
**A macro shot with the maximum D-SLR sharpening applied.**

Over-sharpening an image can detract hugely from the overall appearance. Consider this beautiful elephant hawk moth that my macro photography fails to do any justice to.

The first version has the maximum D-SLR sharpening applied, and it shows in the image above. It is a very sharp image out of the camera, but any manipulation or interpolation will accentuate the sharpening objects beyond what is visually acceptable.

The image below is a version from my 1Ds with the sharpening set to its lowest value. The image still shows good detail, but is not as well defined as the heavily sharpened one. The flexibility of this image, however, is much greater as it can be manipulated before any sharpening is applied.

As with other parameters, the sharpening level can be changed at the browser stage when using the RAW workflow, but this is not

**Fig 4.9 and close-up**
**A different version, with the sharpening at its lowest value.**

the case for JPEGs. Professionals shooting JPEGs always prefer a sharper image out of the camera, as they will do little processing before handing their images over to clients. Personally, I always set my sharpening parameter to the minimum level (my D-SLR does not have an 'off' setting), and always at the finest quality. This allows me to control the sharpening out of the camera and treat each shot individually. I recommend that you do the same whether shooting RAWs or JPEGs – you can always save a JPEG as a TIFF and then sharpen it in PhotoShop. Moreover, it is always best to sharpen an image at the final output stage in your workflow because sharpening precludes further changes.

### Pro Tip

**Most clients in the media industry, which includes photographic agents and image libraries, specify that any submitted images must be unsharpened. The main reason for this is that a sharpened image will not interpolate well compared to an unsharpened one.**

**Set your sharpening parameters to the minimum (or turn it off, if possible) and apply sharpening selectively at a later stage, either in the browser or using tools such as PhotoShop's Unsharp Mask option or third-party PhotoShop actions (see the appendix, page 183).**

## ......The Bottom Line

# ISO and Noise

The sensitivity of a D-SLR to light can be thought of in the same way as that specified for a roll of film. With the latter, as the ISO number becomes lower, the appearance of grain in the final image is reduced. It is no different when using a D-SLR, except that the grain is replaced by signal noise. There are two main culprits to creating noise: high ISO levels and long exposures.

## High-ISO Noise

The higher the ISO sensitivity you select on a D-SLR, the more noise becomes apparent. Check out the examples shown opposite. The top image (and close-up), was taken at ISO 100 with my EOS 10D (and features Muppet, our ever-willing cocker spaniel). The second image (bottom) is from a similar image, which was exposed at ISO 1600. The noise is readily apparent in this image, especially in the darker areas of the fur. The ISO 100 image, on the other hand, is beautifully clean – a testament to the fact that modern D-SLRs produce relatively noise-free images. ISO levels between these ranges show varying amounts of noise, with 800 being similar to the above. If you shoot an image at a high ISO and want to reduce the noise in your final processed image, you have a couple of options. First, RAW browsers like CaptureOne have excellent in-built noise reduction. Alternatively, for JPEG images there are some excellent Photoshop plug-ins (see Appendix, page 183) that will achieve a similar result.

Fig 4.10 and close-ups
This example clearly shows the 'noise' that can be created by using a high ISO setting. The main image (right) was shot at ISO 100, and a second at ISO 1600. The drop-off in quality caused by high-ISO noise is highlighted by the close-ups of the two images, of which the uppermost is the ISO 1600 version.

The problem with all noise-reduction applications, whether in-camera or post-processed, is they can remove vital image data in the mistaken belief that it is noise, although most use very clever techniques to avoid this. Of course, I should mention that high noise is sometimes no bad thing, especially in an image that is later converted to black and white. There is no substitute for the sensor generating high noise and no amount of post-processing techniques can reproduce the same effect. So if you want a high-grain effect, just set a high ISO value and the sensor will oblige!

Avoid using ISO settings above ISO 400 unless you want noise in a picture. Personally, I never shoot above ISO 200 and rarely above ISO 100. If raising the ISO is the only option available to get the a shot, be prepared to accept the consequences. At the end of the day, it's better to have a shot with some noise than no shot at all.

......**The Bottom Line**

**Fig 4.11**
Despite being shot in very low light conditions, requiring an exposure of 30 seconds, this image (taken on my EOS 1D) retains greater detail than a similar shot taken on my medium-format film camera. The ability of D-SLRs to capture fantastic detail at long exposures is one of the real benefits of using digital.

A D-SLR can be used at lower ISO settings than a film camera to record the same detail because it is incredibly sensitive to light and picks up details that a film emulsion would consign to grain. This may sound like a controversial theory, but it is one that I have developed through field experience. I first became aware of this on the dolphin shoot mentioned earlier in the book (see page 23). When one of the images was zoomed to 500%, I could clearly see the outline of someone on the deck of a boat a couple of miles away.

I decided to put the theory to the test on a commissioned job at a cathedral. From a high vantage point in the rafters I set up my EOS 1D and EOS 1V (loaded with Provia 100F pushed to 200) cameras with identical lenses. Then, during a candlelit procession, I took the shot opposite with the 1D D-SLR. The trails that you see are the choristers holding candles. The cathedral itself was in total darkness apart from the candlelight. The exposure for this image was 30 seconds on ISO 200. The detail is phenomenal – just check out the individual people and the clarity of the ceiling architecture. The film version picked out similar detail in the ceiling, but at an exposure of about four minutes the people were indistinct due to grain. Also, at the candle trail was too indistinct, spoiling the effect of the image.

Shooting at a low ISO is one way of reducing the impact of noise in your images. If you limit yourself to ISO 200 and below then you will rarely, if ever, see any noise in your images. Bright blue skies are still prone to noise, even with the latest D-SLR signal processing, but this is still much less so than a scanned 35mm film image. If you do find noise, there are some post-processing techniques that can be used to reduce its effect.

# Long-exposure Noise

The most noise will appear in shots that are taken at night or of dark scenes. Long shutter exposures (typically greater than one second) allow the sensor to leak more signal data, which creates more noise. Note that this is a different kind of noise to the high-ISO variety, and it can have a much more regular (and visible) pattern. There are four ways of reducing the effect of long-exposure noise:

### 1) Use a low ISO
Using a low ISO has already been covered in the section above, but by definition using a low ISO means longer shutter speeds. It's a bit of a catch-22 situation – reducing the effect of high-ISO noise by using a low ISO lengthens the exposure, and therefore increases the effect of long-exposure noise. Fortunately, this noise is only noticed on exposures of over one second or so, and as photography at this end of the exposure scale tends to be planned for, the methods to reduce long-exposure noise as outlined below can be considered.

### 2) Avoid JPEGs in such situations
Avoiding JPEGs for long or high-ISO exposures is a great way to reduce the effects of noise. Due to their compression characteristics, JPEG images can show more noise than their RAW counterparts, so for this application stick to RAWs.

### 3) Use in-camera noise-reduction technology
Using noise-reduction technology (NRT) sounds very grand, but in truth it is simply an extra feature that D-SLRs provide to help

reduce the noise associated with long exposures. Some allow you to switch it on and off at will, others just assume you want it and the processing is internalized. When used, this parameter allows the D-SLR to take two subsequent frames after you press the shutter. The first is your image data; the second is a 'dark' frame, which, as the name suggests, is a frame taken as if the lens cap was left on. The in-camera processing then blends these two images together to remove any 'stuck pixels' and produce an image with less noise than an image without NRT. This is also the most compelling reason to use NRT, as the dark frame can only be effective if taken at the same time as the normal image-data frame.

In-camera NRT has three main problems. First, the D-SLR makes a decision on which pixels in the image are noise and which are image data. Sometimes it can get this wrong, thinking that some detail in your picture is noise and effectively blurring it. Second, the two images are blended together in the buffer, which means that the size of the buffer is effectively halved and the processing time increases accordingly. The buffer-size decrease is not really an issue with this kind of photography, but the increased processing time can have a marked effect. The final issue is that the application of internal NRT is irreversible, even for a RAW image, and once shot there is no going back.

Clearly there are pros and cons for using in-camera NRT. Recent results that I have seen from the Canon EOS 10D show amazing noise reduction (users have no choice with this camera, as NRT is switched on by default). My preferred option, because I have the time and a camera with optional NRT, is to switch this parameter off and process the image out of the camera.

## 4) Keep the D-SLR at a low operating temperature

Keeping the D-SLR cool will reduce the amount of noise in an image, as this worsens with increased sensor temperature. Therefore, get set up for your shot before actually switching on the D-SLR. If you can take your shot within the first few minutes of switching on the D-SLR, the sensor will still be relatively cool and noise-free. Avoid using heat-generating components like the LCD, which sits close to the sensor and will warm up the camera very quickly. Using in-camera NRT on several concurrent exposures will create enough heat to warm your hands by, so don't expect the final image to be as noise-free as the first. Finally, in such situations a CF card is a much better alternative than an IBM Microdrive as the former generates less heat (see pages 44–5).

## Using Noise

There are areas of photography where a little noise is a good thing. Certain images benefit from noise, as it adds mood and additional texture. Consider the example above.

This image was taken some 15 minutes after sunset, from a position lying in front of the giraffes. To get the silhouette I metered from the brightest part of the sky, which I knew would cause the camera to underexpose. The image on the left is a close crop of the

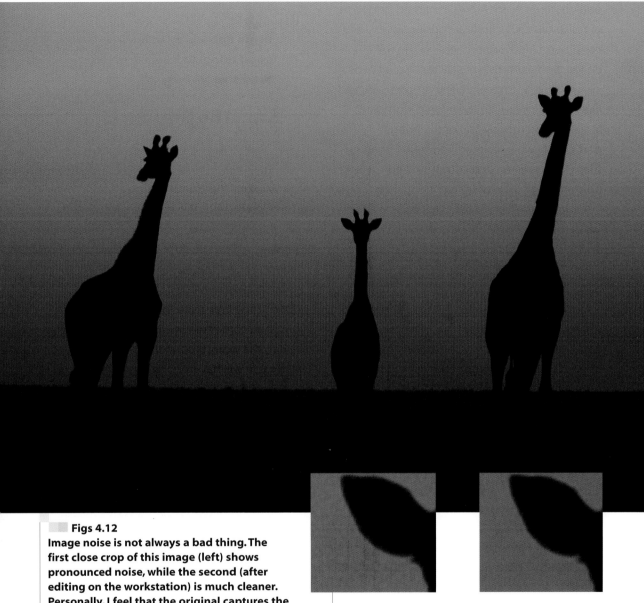

▪ **Figs 4.12**
Image noise is not always a bad thing. The first close crop of this image (left) shows pronounced noise, while the second (after editing on the workstation) is much cleaner. Personally, I feel that the original captures the atmosphere of the occasion much better than a 'sanitized' version could.

original, and clearly shows a marked presence of noise, which is hardly surprising given the conditions. After pre-processing the RAW image with my browser's NR technology, the image looks a lot cleaner. The problem is that I like the grainy feel. To me it looks right and increases the moody feel of the image, particularly when printed. Too much imaging these days is clean and computerized – a little noise gives a sense of reality.

# File Numbering

Every time your D-SLR takes an image it assigns a sequence number to it. This sequence number is the file name that will be used on the workstation. D-SLRs have several different options for numbering, but they all work in roughly the same way. Some D-SLRs specifically designed for press usage, have a prefix that is unique to the camera: 83DS for my EOS 1Ds, B63A for my 1D. This identifies the images as being from a unique camera, something that is important in the manic media world. For the rest, each number starts with a set prefix (DSC_ for Nikon, CRW_ for Canon RAW and DSCF for Fuji) then has a four-digit sequence number between 0 and 9999. When this limit of 9999 is reached the D-SLR will reset to 0000 and therefore create a number for an image that

**Some noise in an image can be a good thing, so be wary of excessive NRT usage.**

## ......The Bottom Line

already exists. This doesn't cause a problem for the files on the D-SLR, even if you leave them stored there for months on end, as they are contained in folders with unique names. Having separate folders is a good approach for keeping two sets of pictures apart, which is useful for the press but has little value for the rest of us. The main issue comes when you want to upload them to the workstation for processing. Sooner or later you will have a conflict between two images with the same name. Although 9999 seems like a high number it isn't – because digital images are cost-free, you will find yourself taking large numbers of them.

A good two-stage solution is as follows. The first stage is to set up the D-SLR so that it continues the sequence number for the maximum time – i.e. it does not reset when a new storage card is loaded. The second is to have a re-numbering policy on the workstation, which gives you more options. Cataloguing will be discussed in more detail on pages 173–5.

### Pro Tip

**Set your D-SLR numbering parameter to 'continuous' or whatever similar option is specified in your D-SLR manual.**

### Pro Tip

**Once at the re-numbering point, your D-SLR will not let you take any more shots until you verify that re-numbering is to take place.**

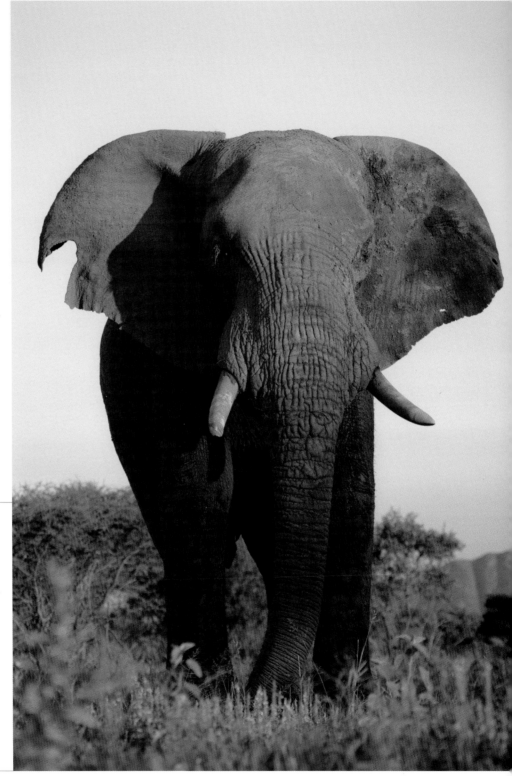

**Fig 4.13**
I love working with elephants; they never disappoint. As this grand chap moved towards me, I selected a focusing point at the centre of his forehead, switched the WB setting to SHADE to accentaute the colour and tested the exposure via the LCD screen.

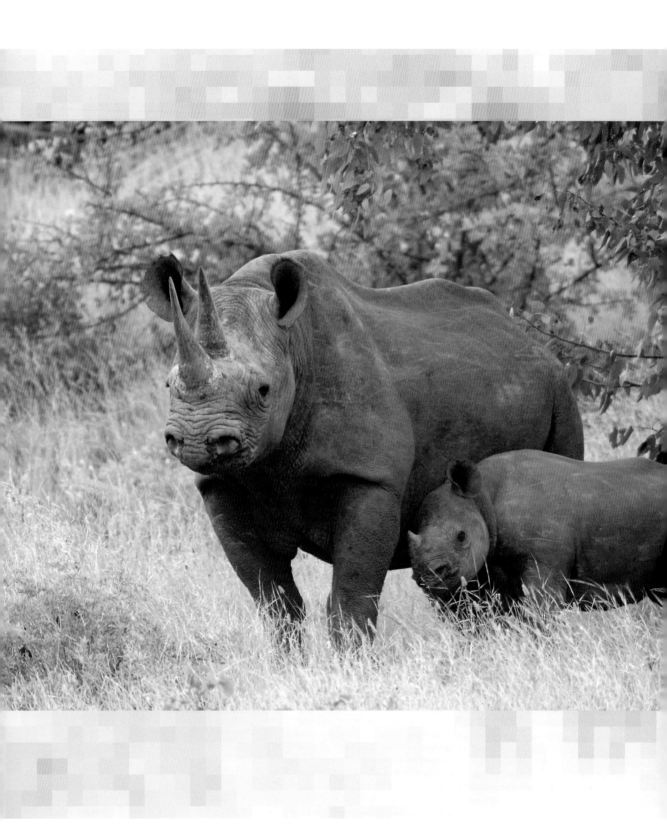

Field Exposure Guide

# Field Exposure Guide

The previous two chapters have dealt with all the set-up issues of a D-SLR in great detail. Now it is time deal with the issues that are specific to using your D-SLR out in the field.

As discussed earlier, the common misconception is that exposure is not important because a digital image can be corrected at a later stage is incorrect – image-processing programs can only do so much. Therefore, getting the exposure of your pictures right is equally as important with a D-SLR as with a film camera. With this in mind, the next couple of pages give a brief introduction to the subject of exposure in a way that aims to simplify a vastly over-complicated subject. This should provide a useful introduction to using your D-SLR effectively and achieving great shots.

## Working with Shutter Speed

Shutter speed is a measure of the amount of time the shutter opens to allow the 'flow' of light onto the imaging sensor. Most cameras have shutter speeds ranging from 30 seconds

**Fig 5.1**
**This herd of Thomson's gazelles were fleeing from an incoming cheetah, so instead of freezing their motion I decided to blur it and emphasize the action. I used a shutter speed of 1/30sec to achieve this, and panned the camera while the shutter was open.**

**Fig 5.2**
**This shot of a tiger shows a different approach. Taken under controlled conditions, a shutter speed of 1/1000sec was used to freeze motion and help to create a more menacing atmosphere.**

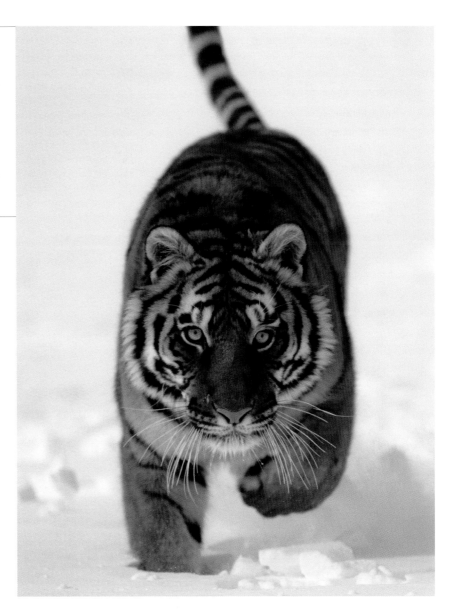

**To create a blurred shot, use a shutter speed of below 1/60sec for most subjects. If you want to freeze motion, you'll need a much faster setting, usually 1/500sec or above.**

## ......The Bottom Line

to 1/4000sec. From an artistic point of view, shutter speed is used to control how you want to depict your subject if it is in motion. Practically, it is also used to minimize the chance of camera shake, which often ruins a potentially great shot.

# Working with Aperture

Aperture, measured in f-stops, is basically used to control the depth of field/area of focus in an image. Most lenses have a minimum aperture of f/4, rising to a maximum of f/22–f/32.

**Fig 5.3**
As I wanted to isolate this European hare from the background, I first selected a large aperture of f/4. However, using my depth-of-field preview function, I found that with such a low f-stop there was not enough depth of field to get both the ears and nose in focus. Therefore I selected a slightly higher aperture of f/5.6, which would still give great background isolation but retain more nose-to-ear detail.

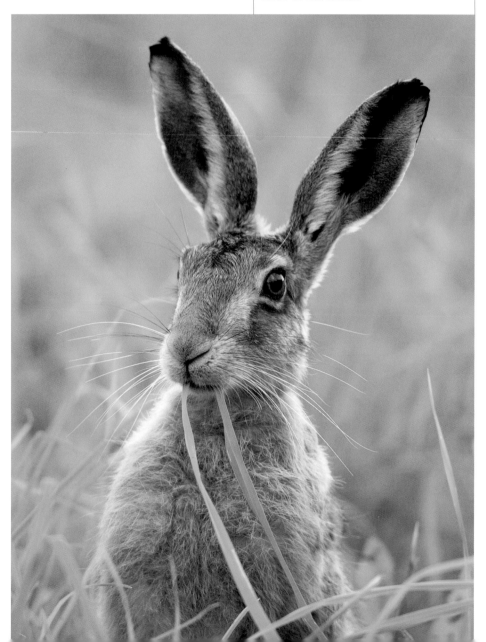

**Fig 5.4**
Landscape photographers generally use high apertures to retain maximum foreground-to-background detail. Here, faced with the enormous distance between the tree at the base of this Namibian sand dune and the summit, I selected the maximum aperture of my EOS D60 (f/22).

To isolate your subject from the background, use an aperture of f/4–f/5.6, but remember to check the depth of field using depth-of-field preview button. Apertures above f/22 should be sufficient for shots that require the largest possible area to be in focus.

# ......The Bottom Line

## Exposure Ratio

Getting the correct camera exposure for a given situation involves a balancing act between the lens aperture and the shutter speed. Although there is only one correct exposure, there can be many combinations of shutter speed and aperture to give this value. For example, a combination of 1/125sec at f/8 is identical to a setting of 1/500sec at f/4, although the final results will be drastically different (because of the difference in depth of field and the effects of motion). This combination of shutter speed and aperture is known as the exposure ratio.

## Program Modes

Most D-SLRs provide a number of program modes that can be used to determine the exposure ratio. They range from fully automated modes (generally identified by symbols of mountains, sprinters and so on), to those that require more creative input from the photographer, such as shutter priority, aperture priority, manual and program. While the former are useful, it is the latter group on which I will base this chapter.

More specifically, I will concentrate on two of these modes: aperture priority and manual.

My wildlife photography has always been based on high-action one-off opportunities, and because of this I have refined my camera usage over time, leading me to forget all the other program modes and do everything that I need with just the aperture priority and manual modes. Using aperture priority I can control the shutter speed, and therefore the look of the finished picture, in an effective and efficient way. For example, selecting a wide aperture (say f/4) gives less depth of field but a fast shutter speed. Selecting higher f-numbers (narrower apertures) brings a corresponding reduction in shutter speed. Therefore, if I want a blurred shot I simply flick the aperture to f/16–f/22, which gives me a slow shutter speed (allowing the effect seen on page 96). Of course, I could achieve the same by switching to shutter priority mode, but this takes time and requires me to take my eye from the viewfinder.

**Pro Tip**

**To select the fastest possible shutter speed, simply select the minimum aperture that your lens allows (usually f/4), while in aperture-priority mode.**

**Pro Tip**

**Learn how to move all your camera controls by touch alone, as you cannot take a shot if your eye is away from the viewfinder.**

**A change in aperture requires a corresponding change in shutter speed to maintain the same exposure ratio, and this may not produce the effect that you want.**

**......The Bottom Line**

## The Light Meter

We all know the problem with in-camera light meters: the exposure ratio that they suggest invariable needs tweaking. Film users have generally grown accustomed to estimating how much tweaking a shot needs, and then dialling this into the camera in the form of exposure compensation. Rules such as '– compensation' for black/dark subjects and '+ compensation' for white/light subjects have become the norm. However, the fact remains that this is guesswork and therefore prone to error.

# The D-SLR LCD

Unfortunately, light meters are no different in a D-SLR and they can still get things wrong. However, the D-SLR allows you to take a 'Polaroid', and you can check out your first image by reviewing the LCD screen. From this you can interpret how your camera's light meter is exposing the scene, and have an indication of the composition and the effect of any filters that you will be using. If you have time to do this before the main action starts then all the better, if not make time for it during the first lull.

**Fig 5.5**
**I used my EOS D30 LCD to check the composition and effect of the Lee filters that I used for this exposure. Once I had the right combination, and the right framing, I transferred the filter rig to my Pentax 645 NII and recorded an identical shot. With the D30 TIFF only being 9MB I was unconvinced about its competitiveness with 645 film, but since then things have moved on and I now shoot landscapes with my EOS 1Ds, using the same technique.**

The LCD has two tools in its armoury to help you determine how your image looks. The first is the screen itself, which allows you to check out the composition, the effects of any filters used, and so on. I first used this feature while on a commission in an African national park – admittedly as a glorified Polaroid to my medium format!

Studio photographers also use this technique to evaluate the effects of lighting on their models or still-life subjects. They have always benefited from Polaroid backs for their cameras anyway, so using the D-SLR for this is no different (except that it saves time and money).

Using the LCD to view your images does, however, have one major drawback: it always shows every image as bright and happy. As a result, it cannot be used to determine exposure with real accuracy.

Fortunately, the D-SLR LCD has a second tool in its armoury to help you fine-tune an exposure: the LCD histogram. This provides a graphic representation of an image's colour range and, if interpreted correctly, can be used help bring greater consistency to your exposures.

The histogram is used after you have taken an image and is available either as a separate function (e.g. the Canon Info button) or as an option under image display (as on Nikon and Fuji models). When viewing a histogram, the horizontal axis indicates the brightness level, while the vertical axis shows the number of pixels recorded for that level. The dark end of the spectrum is at the extreme left, the light is at the extreme right (just remember light is right and you can't go wrong). If you had perfect conditions, you'd see a histogram similar to that below.

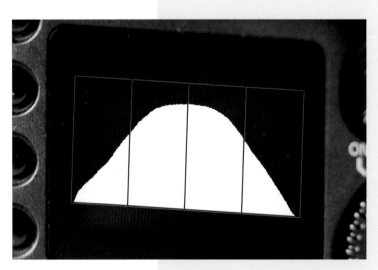

**Fig 5.6**
**This histogram has a bell shape, showing that the average across the whole range is roughly halfway between dark and light. This can be thought of in film terms as medium tone. The even spread of colour means an image with a good proportion of colour throughout the spectrum, without too many extremes.**

**Fig 5.7**
This histogram has most of its pixel density at the dark end of the spectrum; hence it will be underexposed. This is not necessarily a bad thing, as slightly underexposed images can retain more detail. A browser or image-editing problem can also be used to brighten an underexposed image easily without any apparent loss of quality or increase in noise.

**Fig 5.8**
This histogram has most of its pixel density at the light end of the spectrum; hence it will be overexposed. This should be avoided unless you deliberately want to overexpose a shot, as there is no going back from this histogram and little detail will be retained in the final image.

## Using the Histogram

Perhaps the biggest change to your photographic technique in the field with a D-SLR is remembering to use the histograms. It's so easy to fall into old technique and start banging away with an estimated exposure, then realize back in the digital darkroom that a histogram would have saved your images from being poorly exposed.

Tips from professional photographers are a great way to learn new techniques;

not so much because of pros' ability but simply due to the fact that they know the quickest and best way to get consistently good results – our livelihoods depend on it. A couple of fellow pros at this year's Wimbledon Tennis championships told me that most of them spend several minutes before the start of a match taking test images and evaluating histograms. The white clothing worn during a tennis match causes real problems with exposure, especially in sunlight, and solutions for this are covered a little later in this text (see page 108). One of my friends covered the last Olympic Men's 100m sprint final, and spent a total of 20 minutes working with his histograms to get the exposure exactly right. In the ten or so seconds that the race took to complete, those 20 minutes would pay dividends – because he was shooting JPEGs he had no margin for error, especially because the images had to be on the way to his news desk within two minutes of the race finishing. This is a good philosophy to have, and where possible I always take at least one test shot to evaluate the histogram.

**Even the most experienced digital photographers make the time to check out their histograms. If they do it, you should too.**

# ......The Bottom Line

# Evaluating Histograms – Reality

Unfortunately, the histograms shown in the previous examples have been created to illustrate a point, and rarely do I get anything like them in reality. For example, the bell-shaped curve is more often like that shown for the shot opposite.

The basic rule when interpreting histograms is to always strive to get a reasonable colour spread (covering at least two-thirds of the histogram) and with its average slightly to the left of the mid-tone point. This latter point is vital; shooting an overexposed image is a waste of time, unless of course you intend to do so. Once an area in an image is overexposed, the detail is lost and no amount of clever digital-darkroom fiddling can replace it. However, shooting a slightly darkened image picks up extra detail, doesn't burn out the highlights and allows enough latitude for simple brightening in the browser or using PhotoShop. A dark image can easily be brightened up to one stop before losing any quality (more if the image will only be used to make a print). Also, an added bonus of shooting slightly darker is that you gain extra shutter speed.

Histograms come in all sorts of weird and wonderful shapes, but as long as you apply the basic rules above you'll get the exposure that you want. The following pages show some variations of 'good' histograms.

**Fig 5.9**
As I would expect in perfect, sunny light, this is a
very good histogram in terms of colour depth and
range. The average is slightly to the left of mid-tone;
hence the resultant image is slightly underexposed
and perfectly balanced for any later processing that
needs to be done.

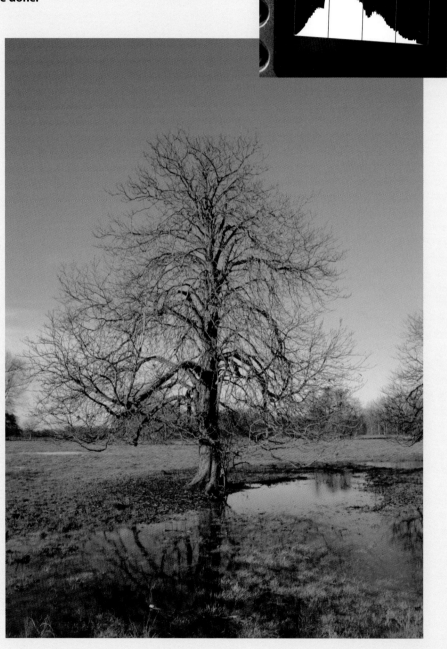

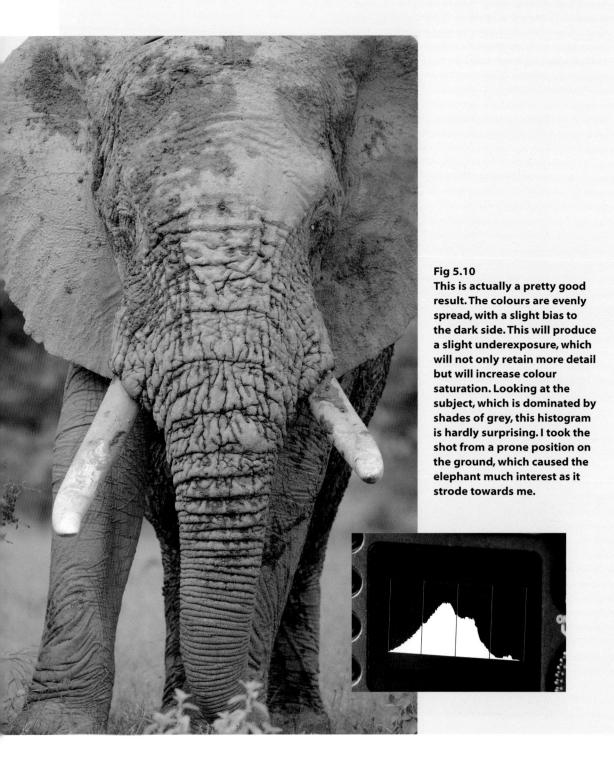

**Fig 5.10**
This is actually a pretty good result. The colours are evenly spread, with a slight bias to the dark side. This will produce a slight underexposure, which will not only retain more detail but will increase colour saturation. Looking at the subject, which is dominated by shades of grey, this histogram is hardly surprising. I took the shot from a prone position on the ground, which caused the elephant much interest as it strode towards me.

**Fig 5.11**
At first glance this histogram appears too dark.
On closer inspection, however, it does contain an
almost complete horizontal spread. The picture is
taken in a dark situation, with lots of dark tones,
which leads to the predominance of pixels to the
left of the histogram. In fact, the only 'bright' tone
is the white flash on the horse's head. Again,
given the situation, this is a perfectly good
histogram and necessitated only a slight
brightening in the digital darkroom before being
used on a calendar.

# Exposing for white

Due to their increased sensitivity to light, D-SLRs tend to burn out highlights very easily. Hotspots of light coming through trees and white skies can cause real problems. This also causes problems when subjects have white or bright colours in contrast with other areas of the image, as it is so easy to lose detail. The major problem in the shot of the bald eagle (below) is the contrast between the bright white head and the dark body. To compensate, if you have white objects in your image, make sure that your histograms are biased the left-hand (i.e. underexposed) side.

# A Practical Example of Histograms in the Field

I always try to practise what I preach, so here's an example of a recently commissioned job where histograms saved the day. I was in the middle of a photo shoot for Le Chameau, an exclusive outdoor clothing specialist, when I was asked to take something creative featuring a wellington boot! After several attempts I finally hit on an idea to have the boot in a small waterfall and blur the water around it. Normally I would have taken such a shot in very overcast light, but the sun was high

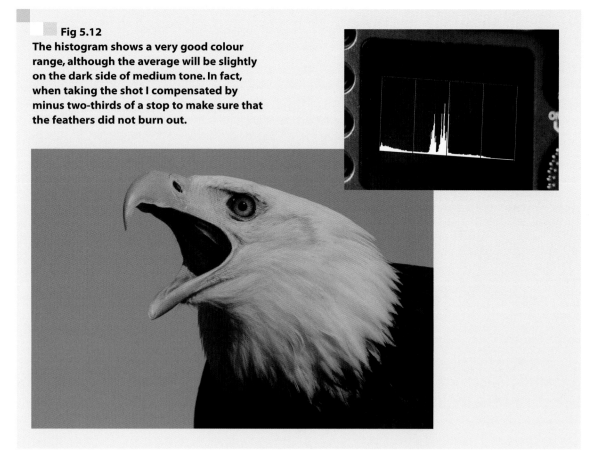

**Fig 5.12**
**The histogram shows a very good colour range, although the average will be slightly on the dark side of medium tone. In fact, when taking the shot I compensated by minus two-thirds of a stop to make sure that the feathers did not burn out.**

**Fig. 5.13**
I noticed straight away that the water behind the boot, and the pool to the left, was burnt out. The peaks on the far right of the histogram confirmed this, even though the colour range was good. I compensated the camera by -1 stop and tried again.

**Fig. 5.14**
This time the histogram was much more to my liking. Its average was to the darker side of medium tone and the peaks on the far right were almost gone. By darkening the exposure from 5 seconds to 2.5 seconds I had removed the burnt-out highlights, at the expense of a little blur. All done and dusted with a few minutes effort.

## Pro Tip

**If you are shooting in constant light (i.e. on a bright sunny day), use the following trick. After figuring out your exposure via the histogram, switch to Manual mode and dial in the aperture and shutter-speed values respectively. In this way you'll be immune from the effects of the meter taking a fancy to something extra bright/dark in the frame and ruining your perfect exposure. I always use this technique in Africa, but just make sure you have constant light.**

in a clear sky and we had a deadline. Once I'd picked the position and the subject was in position, I set up my EOS 1Ds. Since I knew the image would need to be post-processed, I chose to shoot RAW. Also, the harsh light was playing havoc with the WB and I wanted the option to change it later. I knew that in order to blur the water I would need the longest shutter speed available for the light, so I selected ISO 50 and the maximum aperture for the lens of f/32, a combination that would give me a slow enough speed to blur the water. Setting compensation to '0' I took my first exposure, covered my head with a towel and used the LCD to view the histogram. The results can be seen on the previous page.

# Viewing Histograms in the Field

One of the major problems with histograms is not their interpretation, but seeing them in the first place. Even though LCD screens are bright, in direct sunlight they can be almost impossible to see. There are three solutions to this problem:

- The most obvious is to turn up the LCD brightness to its maximum (check your menu options) and try to view it in the shade.

- Sometimes even this doesn't help, so Lee Filters make a special bellows hood that fits over the LCD screen using some Velcro strips. I have used these several times in very bright desert conditions and they work extremely well. My one tip is to attach them only when you need to look at the screen, as they quickly get in the way.

- I have also seen a delegate on one of my raptor courses use a very home-made solution instead of the above: a toilet roll with a loop of string through it long enough to it to hang around his neck. When he needed to view the LCD he just used it like a telescope with one end against the screen. It may look stupid, but it is recyclable and available the world over.

# Histograms – a Summary

- Remember to look at the histogram before doing anything else!
- Don't use the LCD picture display to assess exposure, only use the histogram for that.
- Try to get the average distribution of the histogram to the left of the medium-tone line; remember that dark is good.
- Avoid peaks anywhere near the right-hand side of the histogram (i.e. towards the light end of the spectrum) otherwise severe overexposure can result.
- Assess the scene beforehand so that you are not taken by surprise. If it is a very dark scene, expect to see most of the pixel density over to the left, with perhaps only 50% of the histogram covered.

# Hidden Uses of the LCD

The LCD also has some hidden advantages, particularly for macro photographers.

In this area of photography depth of field is all-important and comes down to a balancing act between getting the subject sharp and rendering the background diffuse. The normal technique is to use a camera's depth-of-field preview button, but at apertures of f/16 or greater the viewfinder image is so dark that it is virtually unusable. Using a D-SLR, however, the LCD will display a bright image at any aperture setting, and can therefore be considered as a replacement to the depth-of-field button. Just set your aperture, take your shot, assess the results (including the histogram) on the LCD, and make any necessary adjustments.

**Fig 5.15**
**Taken with a Nikon D1H and a macro zoom lens, this common spotted orchid makes a beautiful subject. Using the LCD screen, the depth of field was assessed and an aperture of f/8 selected to blur some of the background flowers while retaining sharp focus on the main subject It is also important not to 'overcook' images like this by applying too much colour at the digital darkroom stage – nature has provided enough colour by itself.**
**Photograph © T.J. Rich/ARWP Ltd**

## Using D-SLR Parameters to Affect Colour

Previous chapters discussed the effects of the white balance (WB) and colour matrix/space (CM) shooting parameters. In certain situations, correct usage of these parameters can result in a greatly improved picture. Here are some hints and tips:

- If you want to improve the overall punch and impact of the picture, setting the WB to SHADE or the CM to sRGB will do that for you.
- In low sunlight, setting WB to SHADE will improve the mood and feel of the image. Be warned, however, not to set sRGB in red light as the effect will be too strong.
- If natural skin tones are important, it is best to use a custom tone curve. For most of us, however, a CM of Adobe 1998 and WB of DAYLIGHT/AUTO will yield the most natural results.
- In overcast conditions, sRGB can be used to improve the colour of the image, as can WB CLOUDY.

### Pro Tip

**If you are using this technique, don't forget to delete all your test shots once you have the real one. The following section deals with editing in-camera, while chapter 7 (see page 125) deals with editing them on the workstation.**

The beauty of the D-SLR is that all these parameters are readily changeable, which makes experimentation easy (and fun). RAW shooters can do this at the browser stage if they wish, but JPEG shooters will have to take sequential exposures with the changes made to see the difference. Of course, JPEG shooters could use the RAW + JPEG option to give them the best of both worlds while they are learning which options work best in which conditions. Either way it is worth experimenting, after all that is how we all improve our photography.

**Fig 5.16**
**Taken approximately ten minutes after sunset, this shot shows just how good the D-SLR's ability to capture detail in low light levels is, particularly in the texture and subtle colouring of the hippo's skin. At the time I failed to appreciate the beauty of the scene – it seemed more important that I get out of the water!**

Managing Your
D-SLR in the Field

# Managing Your D-SLR in the Field

Gradually we're forming a good methodology to get that perfect shot. So far we have developed the following process:

- Decide whether to use RAW or JPEG for the shot you want.
- Set up the D-SLR shooting parameters and WB according to the conditions.
- Set your desired ISO, being aware of any noise considerations with increasing ISO.

- Set the camera to AV and dial in your desired aperture, which will vary depending on the shot you want to take. I use f/4 for high action, f/5.6–f/6.3 for most wildlife, f/8 for studio work (depending on effect) and f/22 as a starting point for most landscapes.
- Compose and take the shot.
- Check the image on the LCD and view the histogram to judge exposure.
- Evaluate exposure, readjust exposure compensation if necessary and re-shoot.
- Re-evaluate histogram.

**Fig 6.1**
**Taken in very overcast conditions, this image is nevertheless bright and vibrant – just like the two lion cubs.**

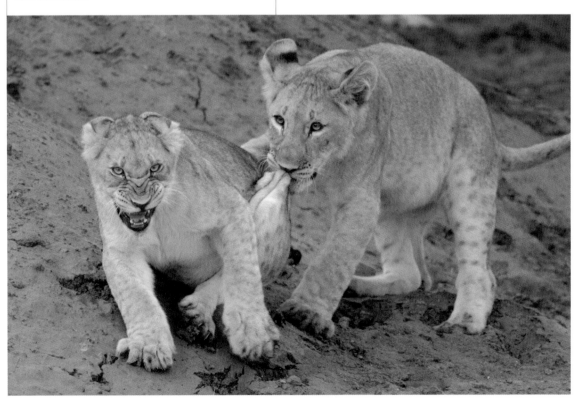

# Snapshot Mode

As a wildlife photographer I always have to be ready to shoot at a moment's notice. The same will be true of your photography, as good pictures are often fleeting moments. Therefore, I always have my D-SLR set up in what I refer to as 'snapshot mode' – primed and ready to take a shot. The assumption here is that the action may be so rapid that you do not have time to check the LCD histogram as you are shooting, but then again you should already have done this with your test 'Polaroid' shot. It is essential that you do this habitually in a new situation. Here are the settings that I use for snapshot mode:

- Set mode to aperture priority and the aperture to f/5.6. This gives a high shutter speed and good background isolation.
- Set exposure compensation to minus two-thirds to ensure a slightly dark histogram. (Note: this only applies if you have not had time to determine the correct exposure via the histogram.)
- Set WB to AUTO for RAW workflow and SHADE for JPEG, assuming of course that you are outside.
- Set ISO to 200 to keep the speed high without generating too much ISO noise.
- Set autofocus to tracking servo, AI Servo or Continuous servo (or whatever it is called on your D-SLR). This is essential, as your camera will always focus quicker than you can.
- Highlight all your autofocus points – if you only have one then don't worry. Again, this is essential as you are putting the camera in complete control and removing the slowest element in the loop (i.e. yourself).
- Make sure you have space on your chosen storage card. This may sound simplistic but you'd be amazed at how easy it is to forget, with disastrous and frustrating results.

If you have a lens-range switch, select the option that gives the shortest range to infinity. For example, if you have 1.5m to infinity and 4m to infinity, select the 4m option. This assumes that you will not have anything closer than 4m; if this is not the case, just keep it on the widest setting. The benefit of selecting the shortest infinity range is that the internals of the lens have a shorter range to move in order to achieve focus. The end result is that you will get your choosen subject in focus much more quickly.

Please bear in mind that these are only general suggestions, which are the result of my own experience. You may find that for your particular form of photography a higher basic aperture is needed – that must be your decision. The most important thing to bear in mind is the classic boy-scout motto: Be Prepared!

# Managing Images in the Field

At this point our shooting begins in earnest, and some real problems can be avoided with careful planning. They can be grouped under the categories:

- Managing Storage Cards
- Downloading Images in the Field
- Preserving Battery Life
- Reducing Dust

## Managing Storage Cards: editing in-camera

Each time you step outside the door with your D-SLR you should format your storage card first. This ensures that you remove any existing files, which may prevent you from adding new images. Of course, in order for you to do this you'll have to get into the swing of off-loading your images to the workstation as soon as you've taken them.

In chapter 3, I showed a table highlighting the number of JPEGs and RAWs that can be squashed on to a 512MB CF card (see page 69). At some point this card will become full and needs to be downloaded to your workstation. This is no problem if you are at home, but not so easy if you are on commission in Outer Mongolia. The obvious solution is to carry a large selection of storage cards, which can seriously affect your bank balance.

The next obvious solution is to edit your images 'in camera' using the LCD screen and histograms to assess their quality. There are three problems with in-camera editing:

- While you can judge exposure and composition via the LCD screen and histogram, you cannot judge focus to any accurate degree.
- D-SLRs provide a zoom function which helps with this, but at the expense of extra battery power. (The LCD drains the battery more than anything else.)
- Excessive usage of the LCD screen warms up the sensor and CF card, both of which can lead to problems with signal noise.

My policy has always been to keep in-camera editing to a minimum, and just use it to remove the obvious howlers. All the rest should be left in place and only deleted in

## *Image Protection*

**Even the worst photographer in the world takes classic images at some point in their lives. With a D-SLR it is amazingly easy to delete these images with a lapse in concentration, but fortunately most D-SLRs provide an image-protection facility. This is a simple menu option, marked with a key symbol (above right), that prevents the image being deleted until it is uploaded onto the workstation. I don't recommend using this feature extensively, but if you get a stunner then find that image-protect key – and quickly.**

the digital darkroom, which will be covered in chapter 7 (see page 125). This means that sooner or later you'll run out of space on the card, in which case you'll need to download your images anyway.

# Downloading Images in the Field

There are currently three options for downloading your images in the field. Remember: the purpose of doing this is to free-up your cards so that you can continue shooting, so it's a good idea to have enough cards to carry on shooting while another is being downloaded. The three hardware solutions are:

## 1) Laptops
Laptops are used to download images by many pros in the field, but generally only when they are within reach of civilization. Download is usually achieved by slotting the card into a PCMCIA adapter. Studio people will often link their D-SLR directly to their laptops, but for most of us this is impractical. I have only taken a laptop on a foreign trip once, to the Masai Mara, with the grand idea of editing my work during the hottest part of the day in the tent. I quickly realized the flaws in this approach. For a start you need power, which most camps don't have in the tents. Secondly, the laptop is fragile. And finally, it is really heavy to lug around. I already have enough kit to travel with and can do without a laptop burdening me even further. I know that several manufacturers offer small laptops now, which are half the usual size, but it is still an additional piece of kit. Manufacturers such

as IOMEGA now offer Firewire/USB hard drives that are designed for the rigours of travel making them reliable and a good external storage medium for the laptop. This is very important when you get home, as they can be connected to your workstation and your images downloaded for editing. Without one, the only option is to burn lots of CDs, which is a time-consuming process.

## 2) Portable Hard Drives
Portable hard drives have really come of age now and are the medium of choice for most travelling and outdoor digital pros. As their name suggests, they are simply miniature hard drives placed in a separate casing. They all have slots to take a variety of storage formats, and you simply slide in your card and press the 'Copy from card' option on the menu. They usually take several minutes to download a 512MB card, then another minute or so to verify that the data has been downloaded successfully. This verification step is usually another menu option and it vital to ensure that the hard drive has taken your images successfully. Once you are back at home you can usually hook these devices up to your workstation via Firewire or USB 2.0 and download the images straight away.

Drives come in a multitude of sizes. I use a 20GB NixVue Vista, which I chose not only because it operates from a rechargeable

**Pro Tip**
**I carry my downloader in a small padded pouch on my waist so that it is always handy.**

battery (giving around six to seven downloads per charge) but also because it has a standalone mode too. This means that I can attach an external AA battery pack and power it up in the middle of nowhere. All of these devices come with an in-car charger too, which is a vital purchase. The great thing about these units is their portability, compact size and large capacity. They are also only used for a single purpose, so hopefully should be more reliable than a laptop.

Of course, hard drives do fail, but I have used these devices to store my images on trips all over the world with only one hiccup. Even on this occasion, I had a hard drive failure but the vendor was able to retrieve my data. This is why the verification step is so important – if the data is on the drive it can survive 99% of the possible failures. If you do get a failure, don't panic – there is a good chance it can be rectified (see page 173).

### 3) Portable CD Burner

The third download option is a standalone CD burner. These have been eagerly awaited, and 2003 saw the launch of the first totally standalone unit, the Apacer CD Steno. The only difference between these units and portable hard drives is that they burn multisession CDs. The advantage of

this approach is that if you damage the unit, your images on CD are still safe. They also appeal to those people who need a CD burner anyway, as it can be used in R/RW mode when attached to a PC or Mac. The downside is that you have to carry around a stack of CDs with you. The Apacer unit is powered by a rechargeable Li-on battery, which during my tests managed to burn nine CDs with 512MB of data on each before being discharged.

### ......The Bottom Line

# Preserving Battery Life

The problem with D-SLRs is that they have heavy power requirements, more so in most cases than off-the-shelf batteries can provide. Most D-SLRs now have Li-on rechargeable packs, which extend their life, but most are lucky to cope with 500 shots on the same charge. Of course, this varies according to how you use the camera. For example, using tracking autofocus and a 500mm lens to cover a sporting event will be a huge drain on batteries. CMOS sensors (see page 30–2) have helped this problem to a degree, but it still remains an issue that needs to be planned for.

To help preserve your battery life, forget about using all the snazzy playback options for your images, unless you are at home and the D-SLR is connected to the mains electricity supply. The worst culprit is the 'Review' option, which controls how the image is displayed on the LCD menu after you've taken it.  Having it displayed after every shot is a waste of battery power and also causes heat problems. Switch this option to OFF and display the histogram when you need to by manually selecting it (see your manual for further details). The latest D-SLRs all have integral zoom functions that allow you to zoom into your images. In reality these are rarely useful and you should save image assessment until you have them on your workstation. After all, isn't is better to have enough battery power left to get a few more shots?

## Charging Batteries in the Field

Just a few words of wisdom from one who has stressed about batteries in some very remote corners of the earth. One of my major concerns with a D-SLR is that it is power dependant – i.e. you can never go more than a couple of days without access to power. Fortunately, I usually travel in an off-road vehicle, and therefore have access to power all the time. The problem is that most D-SLR manufacturers do not provide a car adapter to power their cameras directly from the cigarette-lighter socket. Once again working professionals have provided the solution, this time in the press sector. As they are always on the move it is a requirement that they charge batteries from the car. Most now use a device called an inverter. One end of this plugs into

## Pro Tip

**Whenever you can, use a mains socket for charging equipment and downloading images. I always hunt down the nearest plug at airports to top up my charge – it's amazing what you can find if you look hard enough behind the perfume counter!**

**To preserve batteries, don't use the LCD menus unless checking histograms or making changes to shooting parameters. Avoid the temptation to fiddle with your camera and find something else to photograph instead.**

## ......The Bottom Line

the socket and the other has a plug that matches your normal household one. While working in South Africa earlier this year I had a four-way power connector attached to the inverter, from which I simultaneously charged my batteries and powered my camera and downloader. These inverters are great; I used them for a month in Namibia last year when I was on the road constantly and without mains power. They are also very cheap!

## Reducing Dust

Dust is the enemy of D-SLRs, and the sensors just seem to attract it like a magnet. The penalty for not cleaning your sensor – just as for not keeping your lenses spotless – is hours of tedious tidying up using a program like PhotoShop.

All D-SLRs provide a way of accessing the sensor so that you can clean it, usually via a dedicated menu option. The Olympus E1 has a smart internal 'supersonic' cleaner that vibrates the sensor when the camera is turned on to shake the dust loose.

### Pro Tip

If you are travelling and planning to use chargers, it pays to double up on all cables – they can easily get damaged and may be difficult to source locally.

Most D-SLRs basically perform a mirror lock-up, revealing the sensor to the outside world and all that lovely dust. Adhere to the following rules and you can't go far wrong:

- Never clean the sensor with a cloth.
- Never clean it with your fingers.
- Never clean it with lens-cleaning fluid.
- Never clean it with marmalade – yes one manufacturer had a sensor sent back for cleaning that was smeared with marmalade. Heaven knows what ended up on the toast that morning.
- Never use a can of compressed air as these have a habit of spraying water droplets all over it.

**Fig 6.2**
**This image, taken in the Masai Mara, shows the effect of dust on the D-SLR. I had cleaned the camera a few hours previously and the damage was caused by a single lens change in a dusty vehicle. The problem is not so much that of the lens but that of the sensor, which must be cleaned regularly. All D-SLR manuals contain a section called 'Sensor Cleaning', which I urge you all to study. It does not make the most captivating read, but it will save you time and money.**

Camera manufacturers will charge a lot for cleaning a sensor, but there are two really simply ways to remove dust:

- Use an air blower. This is much more powerful than a blower brush, and it will get rid of all but the most stubborn dust. Just remember to hold the camera upside down to let it fall out. As soon as you've finished, put a lens on the camera to stop any more dust sneaking in.
- Minimize it in the first place. Use the air blower to clean the lens element that attaches to the camera, as dust on this will fall straight onto the sensor during exposure. Metal fragments will also fall from the lens each time you attach it to the camera body, but there is little you can do to avoid this.

In a dusty environment don't even consider changing lenses or using the air blower (it will simply blow dust onto the sensor) – just resign yourself to workstation time.

## Managing Lockout

Chapter 2 covered the issue of buffers within the D-SLR (see pages 39–41). To recap, the buffer acts a temporary store for your images

**If you clean the sensor and lens often, using an air blower as described, your time spent in PhotoShop will be greatly reduced.**

## ......The Bottom Line

before they are written to the storage card. It allows you to shoot your D-SLR in a burst, perhaps as many as 30 shots depending on which D-SLR and storage format is being used at the time. Once the buffer is full, it takes away user control from the shutter functions and writes your images to the storage card (this is the part called 'lockout'). Depending on your D-SLR, you are then either faced with a short wait while it writes the whole buffer, or an even shorter wait if it frees up buffer space as it goes.

For normal shooting practice, it is unlikely that you will ever encounter lockout, as the time between consecutive shots is long enough for the D-SLR to complete its processing. The problem only arises when you shoot a continuous burst, perhaps of a bird in flight or your kids playing in the garden. Nothing can be more infuriating than seeing a great shot, pressing down the shutter button and having 'Busy' flash at you in the viewfinder. Due to the unpredictability of nature, lockout affects me perhaps more than most photographers, but I have learnt to deal with it and manage its effects. Here are my hints and tips:

### 1) The Right Tool for the Job

The most obvious thing to say is that if you are a high-action photographer, perhaps in sports, you need to have a D-SLR that is right for the job. High-throughput D-SLRs with large buffers and fast drives are perfect for the job. There is still some pay-off between resolution and speed, and it is simply a question of which you need to get the job done. Some faster D-SLRs produce such small file sizes that clients aren't willing to accept the files without interpolation (see page 24).

## 2) Shot Selection

In my previous book, *Life in the Wild: A Photographer's Year* (ISBN 1 86108 268 1), I described how a change to Pentax 645 medium format gave my wildlife photography a new edge. Instead of relying on a fast 8-fps motordrive to get me the shots, I had to use a 2-fps drive, and also cope with slower autofocus. It forced me to think about shot selection and capturing the image that I actually wanted. This philosophy has helped me a great deal with managing D-SLR lockout, as now I only shoot when the picture looks good. This means no more blasting away and hoping; I pick what I want and nail it (most of the time anyway). Cutting down on unwanted images is an important trick. Not only does it free up more space for the best shots, it also cuts down the amount of post-processing time. Here are some practical tips to help you cut down on unwanted images:

- If you are tracking a moving subject and your autofocus doesn't lock on to it, don't shoot it. No amount of sharpening will be able to rescue an out-of-focus shot.
- Watch the backgrounds for hotspots (use the LCD display to verify this if necessary). Move position if you have any, as they will detract from the final shot. If you can't move then wait until your subject does. Either way, be aware of the background.
- Don't bracket your exposures, because you should have already determined the correct exposure using the camera's LCD histogram. Any slight adjustments can be made in a matter of seconds at the digital-darkroom stage.

# Chapter Summary

Most of the information contained in this chapter should become second nature. Until then, here is a summary of the main points:

### LCD Screen

- You cannot judge the exposure of an image based on how it appears on the LCD screen. Just use it for basic composition and perhaps for checking obvious background distractions.
- Avoid excessive usage of the LCD screen. It drains the batteries and causes heat in the sensor, which can lead to increased noise in your images.
- To preserve battery life, turn the LCD Review option to OFF and only review images manually when necessary.

### Histograms

- The LCD histogram is the only sure-fire way to determine exposure.
- Try to shoot a histogram where the average is slightly to the left of centre. Remember: dark is good.

### Dust

- Only clean the camera's sensor with a manual air blower; never touch it or use compressed air.
- Ensure all lenses are scrupulously clean.

### Field Exposure Guide

- Use the PROTECT function of your D-SLR to prevent your best images being accidentally deleted in-camera.
- Always format your storage cards before each new use.

## Managing Lockout

- Be selective – only shoot the picture when it looks good, don't just blast away and hope.

## Managing Colour

- Don't be afraid to experiment with the WB and colour matrix settings of your D-SLR; photography is always a journey of discovery.

**Fig 6.3**
Sometimes it is best to let nature provide all the colours that you need. It was late in the evening by the time I found this red grouse roosting high on the Yorkshire moors in North England. The light was perfect and to accentuate its effect on the grass I took the shot from a low angle.

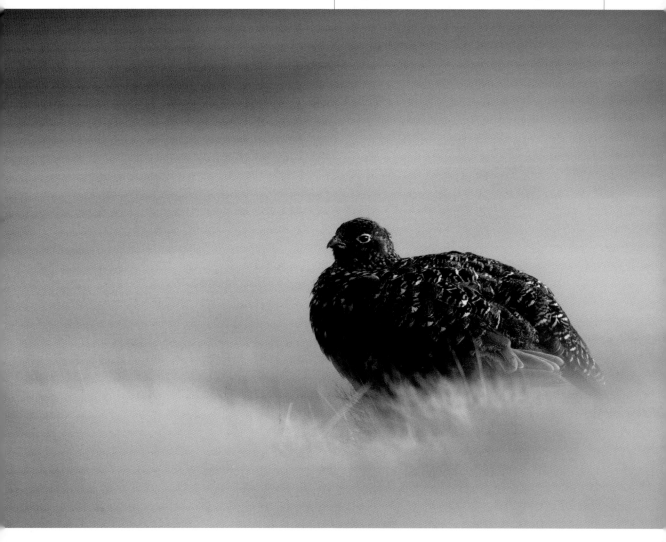

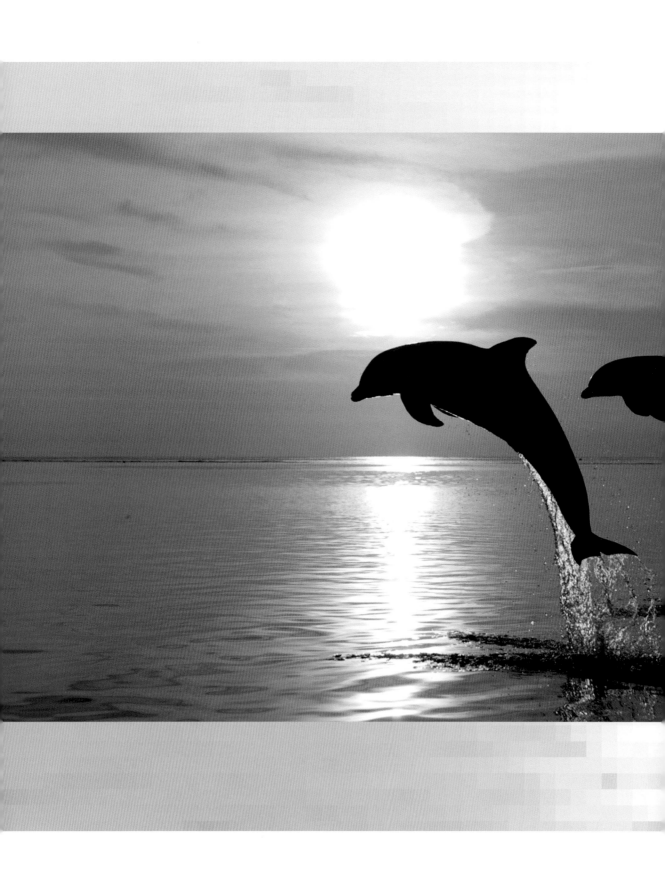

# The Digital Darkroom

# The Digital Darkroom

No matter how careful you are about shot selection, the temptation to take pictures with a D-SLR is overwhelming. Not only is it fun to use, you can take as many pictures as you want without any additional cost – or so you think. The hidden cost is processing time in the digital darkroom. I must have taken over 500 shots with my 1Ds in a single day on a recent shoot of a swooping falcon, which tested my abilities to the limit because of the speed of the bird's flight. As a result I kept less than 20, and only had one that is likely to earn money. Keeping all 500 would have meant using about 16GB of storage space on my PC; keeping 20 meant just over 0.5GB. This just goes to show how vital a strict editing policy is to managing your workstation effectively. The more your workstation fills up with 'near misses', the less space is available for masterpieces and the slower it will run. Eventually, without proper management, it will grind to a halt. This may seem like common sense, but it is common sense learnt from experience of a complex subject.

The bulk of this chapter concentrates on the issues surrounding image editing, and suggests several workflows to achieve a finished result in the minimum possible time. JPEG workflows have the shortest shoot-to-print time, and as such have the simplest workstation processing. RAW workflows take more time, and the workflow shown here is as simple as can be. Each of the workflows, whether RAW or JPEG, are covered in extreme detail, as many photographers reading this

book are new to digital capture. For this I do not apologize – I wish someone had shown me all this stuff when I started instead of having to figure it out for myself.

The one thing about editing is that if you ask ten photographers how they do it, they will all come back with different solutions that are 'the best'. The key here is that there is no perfect way to edit your pictures, only the way that is best for you, your photography and your spare time. Therefore I have decided to put forward several different approaches to editing, to give you the maximum pool of knowledge from which to find your best method.

The next chapter (see pages 166–79) takes the workflow to the next stage by dealing with issues surrounding finished images, such as storage, back-up, visual management and image distribution.

# Common Ground

Whether you choose the simplest or the most advanced editing workflow, there are some basics that you need to be aware of first.

## The Browser

The browser is a software application that is vital for the management of your images. They are usually very graphical, displaying all your images as thumbnails using a standard directory tree structure. Browsers come in varying levels of complexity, from the very

basic that just allow you to collect and print images, to those allowing high levels of image manipulation and processing.

All D-SLRs come supplied with a browser on one of the CDs that arrive with them. Some are very well written and provide a useful function, while others make the whole editing process overly complex. The first JPEG workflow that I will outline is perfectly suited to using any one of these supplied browsers, although the examples shown use Nikon View. A simple RAW workflow could also use one of these browsers too, and I'll cover the pros and cons of this approach later in the text (see pages 147–61).

While some camera manufacturers, for example Nikon and Fuji, offer add-on browsers, most professional photographers use independent browsers for the RAW workflow. The most common are BreezeBrowser, CaptureOne DSLR, Adobe RAW, Bibble, FotoStation and ACDSee. They are all different, they all have their pros and cons, and you'll know straight away which one works best for you. For the record, I use two programs: BreezeBrowser (for file management) and CaptureOne (for RAW conversion).

**Fig 7.1**
**This shot shows CaptureOne DSLR. It's flexible, simple to use and produces great results with a minimum of effect.**

The ability to adjust shooting parameters specified in the D-SLR has been shown as a major benefit of the RAW workflow throughout this book. This may have made the browser sound overly complex; it is in fact a very simple tool to master. Provided your D-SLR has been set up correctly, most of the changes that you will make to your RAW images will be cosmetic. Therefore, for most of us a little tweak here and there is all we need, and a browser is perfect for the job. If you need to do more extensive manipulation, you can use the browser to provide the starting image and immerse yourself in an image editor.

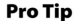 **Pro Tip**

**When you're buying an independent browser, check that it supports your D-SLR and workstation operating system.**

## The Image-editor Application

An image editor's primary job is to clean and colour correct an image ready for printing and/or distribution. Its secondary function is to allow the manipulation of an image to your hearts content. You can stretch, shrink,

---

*EXIF, Metadata or Shooting Data*

**As an author and a regular contributor to magazines, one of the banes of my life is trying to remember shooting information for captions. The D-SLR records all the shooting information for every image and transfers it across to the workstation with the images. This information can be displayed from within any browser, image-editing program or operating system. This screen grab (right) shows the type of information recorded.**

**Full details are given for both exposure and the camera, plus (depending on the manufacturer) any custom function settings that you have in place. If you are shooting RAW, this data can be accessed at any time from your browser.**

**EXIF Data**

File: c6500.tif.tif
File size: 18.0MB
Image Serial Number: 175-7522
Camera Model: Canon EOS 10D
Camera serial number: 0230102575
Firmware: Firmware Version 1.0.0
Date/Time: 1980:01:01 00:02:30
Shutter speed: 1/640 sec
Aperture: 11.0
Exposure mode: Av
Exposure compensation: -2/3
Flash: Off
Metering mode: Evaluative
Drive mode: Continuous
ISO: 200
Lens: 70.0 to 200.0 mm
Focal length: 200.0mm
Subject distance: 0.33 m
AF mode: One-shot AF
Image size: 3072 x 2048
Image quality: Raw
White balance: Unknown
Saturation: Normal
Sharpness: Normal
Contrast: Normal
Custom Functions:
CFn 6: Shutter speed in Av mode: 1/200 (with flash)

re-colour, blend, blur or make water droplets from pictures, to name but a few techniques. The only limit is your own imagination.

Adobe PhotoShop dominates the professional photography and graphics market and provides seemingly limitless manipulation possibilities, but at the cost of several hundred dollars for a license it's expensive for an amateur photographer. The next price-bracket down covers image editors like JASC Paint Shop Pro and Adobe PhotoShop Elements. Both are excellent packages, providing everything necessary for all but the most demanding amateur photographer. While owning the full version of PhotoShop may be seen as better, most of its users only ever use a tiny proportion of its amazing functionality and would be equally happy with PhotoShop Elements or Paint Shop Pro.

**For the vast majority of digital photographers an editor like Adobe PhotoShop Elements or JASC Paint Shop Pro will be more than sufficient for your needs.**

## ......The Bottom Line

## Directory Structure

The directory structure that you use to store images on your workstation can be as simple or as complex as you like. The one basic requirement is that you separate out the original files (RAW or JPEG) that you've downloaded from any that you generate subsequently. Accidents happen and it's vital to have the original to revert back to.

At its simplest level, the directory structure can be thought of in the same way as an office filing tray – In, Pending and Out. In our

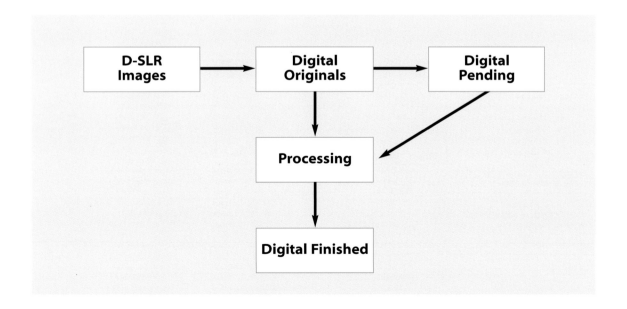

case it will be Digital Original, Digital Pending and Digital Finished, as shown in the diagram on the previous page.

RAW files or your original JPEGs from the D-SLR can be loaded into the 'Digital Originals' folder, while your processed/finished files reside in 'Digital Finished'. It is unlikely that you will download and process all your images into 'Digital Finished' in one session, therefore anything that has been downloaded but is yet to be worked on/printed is moved to 'Digital Pending'. This method is by far the simplest to manage and will ensure that you don't miss a vital file. For prolific shooters and professionals this may not be complex enough, and a more flexible approach is discussed on page 162.

# Image Download

The first step of any workflow is to copy your images onto your workstation's hard drive. It is much quicker – and safer – to work with your images if they are stored on your workstation than on a portable storage device or storage cards. Getting your images onto the workstation is a simple task. Most photographers use their browsers to manage this process. I have included this section as a failsafe for those of you who find that your supplied browsers make even this simple

**Fig 7.2**
**Windows Explorer provides a quick and easy method for downloading your images.**

task seem difficult. The simplest way of getting your images onto your workstation is to use its 'drag-and-drop' capability. An example of this, using Windows Explorer on the PC, can be seen in Fig 7.2.

The image files (listed on the right) sit on a storage card called EOS_Digital, which is inserted into a Firewire card reader connected to the workstation. The files are simply selected (CTRL-A) and dragged into the 'Digital Originals' folder on my workstation. If you choose to have your D-SLR connected directly to the workstation,

or are downloading from a portable storage device, the directory structure will look identical. The workstation sees only an external hard drive, not the device that is wrapped around it.

An alternative is to use the visual look and feel of a browser, such as Adobe PhotoShop Elements file browser, which is shown below.

**Fig 7.3**
**Browsers like PhotoShop Elements provide an alternative method for downloading images, and their highly visual display can be used for other applications (see page 135).**

## Numbering Considerations

The D-SLR produces a sequence number for each photograph taken, and this sequence resets itself when you change cards or when it gets to the maximum limit. To avoid possible repetition, a good solution is to start with a new numbering policy with a wider flexibility than that provided by the D-SLR. Which numbering system you choose is up to you, but here are a few suggestions:

- Limit yourself to eight characters in total, which will allow you to stick to ISO 9660 standards for CD distribution. When you burn a CD, there are two main options you can choose for the CD format: Joliet and ISO 9660. The default is usually ISO 9660, which allows your CD to be read by most, if not all, PCs and Macs worldwide. When I send images to clients they are always on ISO 9660 CDs. The downside is that you can only have eight-character filenames. The Joliet format does not have this filename restriction, but has limited distribution (i.e. to some PCs only).

- Choose one that is simple and will last. Remember: you will only rename the best images, not every picture you ever shoot. The most common conventions are to use either eight digits (i.e. xxxxxxxx), or a combination of one alphanumeric and seven digits (i.e. Axxxxxxx).

## Editing Images

This is perhaps the most subjective area in the whole book, as what is a great image to one person is a shocker to someone else. When you edit your work it pays to be objective. If an image is a near miss, smile, work out what what went wrong, learn from it and press the delete button. Here are some questions to ask yourself when editing images:

- If the subject has a face, are the eyes in sharp focus? If so, is the nose in sharp focus too? Unless the answer to both questions is yes, this image needs to be deleted, as an out of focus nose looks pretty obvious on a print. Next time you shoot a similar subject, make sure that you use a decent depth of field – at least f/8.

- If the subject is in motion is it relatively sharp and in focus? Can you clearly see what it is? If you were panning to get a blurred image, did the effect work?

A lot of my high-adrenaline, dangerous animal work wouldn't win any awards for composition, but given the situation they are great images in my terms. Furthermore, it is very easy to crop an image to make the composition more attractive using some pretty simple PhotoShop tools.

The real shockers are usually easy to determine; the problem often comes when trying to assess finer detail. The following are a couple of ideas that you might find useful to compare your images to.

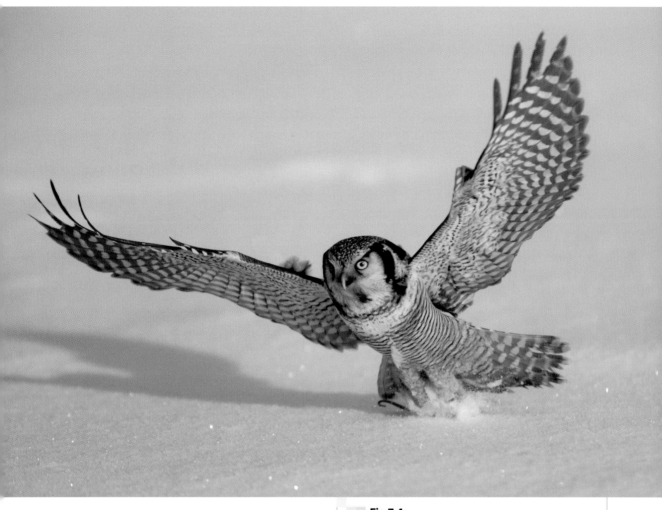

**Fig 7.4**
**One of my top shots of 2003. I managed to capture this hawk owl at the moment of impact. Setting up the shot beforehand, I selected a shutter speed of 1/4000sec and set my focusing to AI servo to track the owl all the way. It still required split-second timing, proving that digital doesn't take all of the skill out of photography.**

## 1) Browser slideshow

Most browsers worth their salt have a slideshow option, which most photographers ignore thinking that it is a gimmick. In fact, it is a great way to edit your work quickly. Simply select all your images (CTRL-A), hit the slideshow option and your images should appear full screen. If they are JPEGs they will load straight away; RAWs are temporarily converted to TIFFs with the shooting parameters applied. Scrolling between images is usually via a mouse click, and images can either be deleted immediately or marked for deletion later.

## 2) PhotoShop Tile

Most of my editing time is spent assessing 'similars'. These are duplicates that occur when the shutter button has been pressed a number of times when shooting a static subject. Consider the screen grab below, which contains two images that looked identical when viewed in the browser.

These images show water droplets on a leaf taken using my Tamron Di 180mm macro lens. I have loaded them both into PhotoShop and used the Tile Option (Window-Documents-Tile) to display them side by side. Then I used the magnifier tool to zoom in on a similar area of both images. You can clearly see that the image on the right is by far the sharpest. This is common with macro work where a breath of wind can ruin everything; one image will often stand out from the rest, and everything but the best needs to be deleted. This is one area where I use PhotoShop extensively, particularly because I am looking for very high levels of detail at high magnifications.

**Fig 7.5**
**The PhotoShop Tile option, though not as quick as a browser slideshow, allows you to view images in much greater detail – particularly useful when comparing two very similar shots.**

## PhotoShop Configuration – 16-bit Editing

PhotoShop allows to you to work with images in either 8-bit/channel or 16-bit/channel mode. In a nutshell, using 16-bit mode means a smoother transition between colours and therefore – in theory – a higher-quality result. The problem is that converting a file to 16 bits doubles the file size, which may slow your workstation down. If you intend to manipulate an image in PhotoShop, it is advisable to convert it to 16 bit, do your manipulation, and then re-convert back to 8 bit. Not all PhotoShop functions are available in 16-bit mode, but those needed for colour correction certainly are. Most browsers allow you to convert a RAW image to either 8 or 16 bits. Therefore, if you intend to manipulate any image to any extent it makes more sense to convert it to 16 bits at the browser stage with the RAW image data, rather than after conversion in PhotoShop.

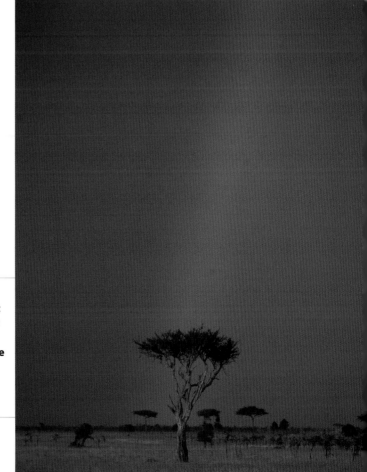

**Fig 7.6**
This image, which was taken during a violent thunderstorm in the Masai Mara, will benefit from being converted into 16-bit mode for any manipulation. The transition between the colours at the edge of the rainbow are so subtle that 16-bit editing is the only way to preserve them.

# Simple JPEG Workflow 1

This workflow is the simplest and has the shortest time between getting the JPEG onto the workstation and printing out a finished image. This suits a lot of amateur photographers who simply want to enjoy their photography and get some nice prints with the minimum of fuss. It requires no intensive computer knowledge and there is no need to purchase any additional software, as everything needed comes supplied with the D-SLR. For the purposes of this example

I will use Nikon View, but you could achieve the same with Fuji FinePix Viewer or any other manufacturer-supplied offerings.

### Step 1 – Download image files to workstation

The first step is to download the files from the storage card onto the workstation. The browser window looks as shown in Fig 7.7.

Using the tree structure, I selected all the JPEG images on the storage card (CTRL-A), and then dragged them into the 'Digital Originals' folder.

**Fig 7.7**

## Step 2 – Delete shockers

Now it's time to identify and delete the shockers. Some will readily identifyable, but the best policy to is set the browser to display the thumbnails at the maximum size as shown in Fig 7.8.

At this stage it is impossible to tell if an image is out of focus, so we're looking for the obvious shockers, like those showing a blank frame or severe exposure. In total I found three shockers in this selection, then selected and deleted them as shown in the screen grab below.

**Fig 7.8**

**Fig 7.9**

**Fig 7.10**

## Step 3 – Image zoom

Now use either the slideshow function or just double click on the image to get a full screen representation of it (Fig 7.10).

Simply scroll through the images, using the zoom function to inspect fine details at 100%, and refine the selection of images for deletion. When you find shockers – like this out of focus image (Fig 7.11) – delete and move onto the next.

## Step 4 – Minor corrections

Now all the shockers are gone we only have the good stuff left. While most are probably OK, some will need minor corrections such as a touch of brightening. Most browsers allow basic editing of this type, usually by launching to another editor window, as shown below.

**Fig 7.11**

**Fig 7.12**

Corrections are made by using a slider. Make sure that you activate any 'preview' options so that you can see the outcome of your changes. Here I have changed the brightness and added some red to the orchid's colour. Those familiar with PhotoShop will see the icon on the toolbar at the top of the frame, using Nikon View it is possible to launch straight into this application. This can also be used to 'clean' the images of dust and scratches before printing.

## Step 5 – Printer profiles
This method works best if you specify a colour matrix/space parameter of sRGB in your D-SLR. Since your inkjet printers will use a basic sRGB profile (if you are unsure, try

assigning them one from their Properties tab), as long as you maintain sRGB throughout, the print should look OK. Of course, this depends a lot on how the individual browser handles printer management. Unfortunately, the best way to find out is by experimenting. If you want to achieve more consistent results, read the section on printing (see page 164).

This will not achieve perfect results, but they will probably be good enough. Should you want to improve your results, however, most browsers allow you to specify profiles for your monitor, printer and workspace as shown in Fig 7.13 (below).

**Fig 7.13**

**Fig 7.14**

## Step 6 – Renaming and moving a printed image

If you made a change to the JPEG file, you obviously need to save it to record those changes for future use. This also provides an opportune moment to rename the file, as shown in Fig 7.14 (above).

The most important point to remember is that saving a JPEG will degrade it slightly, so ensure that you save it with the maximum quality options set. At this quality level the file will be visually lossless as discussed in chapter 3 (see pages 59–62). In order not to overwrite the original JPEG that you took in the D-SLR (assuming that you didn't rename it), save this file to the Digital Finished folder.

If you intend further manipulation, it may be advisable to save it as a lossless TIFF, although this will create a much larger file size.

## Step 7 – Moving unfinished images

If you do not intend to process and print the remaining images in the 'Digital Originals' folder until later, move them into the 'Digital Pending' folder. This frees up the originals folder to receive more images as you take them. Don't forget, however, to go through the pending folder periodically and finish off everything. This is good management practice and prevents a backlog from building up.

# PhotoShop JPEG Workflow

This is a slightly more complex workflow than the previous one and is perhaps more suited to the serious JPEG photographer. In fact, it is purposely designed to retain the original image quality of the JPEG file for the purpose of further manipulation. It is based around the PhotoShop 7.0 File Browser, which has really changed the way that this product can be used. Note that PhotoShop Elements has a virtually identical browser and so this workflow applies equally to this product. If you use Elements for this workflow you might also want to consider Adobe PhotoShop Album to work alongside it, as they work well together and perform a lot of complex tasks with just a few mouse clicks.

## Step 1 – Download image files to workstation

The first stage, as always, is to get the JPEGs from the storage card onto the workstation. The PhotoShop File Browser is used to display the directory tree, as shown below.

As always, select all the files from the card (CTRL-A) and drag them into the 'Digital Originals' folder. Sometimes the PS browser can be slow to react to changes, so if it doesn't show the card reader when it is first attached just hit F5 (refresh).

**Fig 7.15**

**Fig 7.16**

### Step 2 – Delete shockers

The next step is to delete the obvious shockers (Fig 7.16).

On my monitor I could clearly see that in one image the expression on the little chap's face wasn't one he'd like to remember, so I selected the image and hit delete. At this time this was the only really obvious shocker as I'd edited most in-camera (I was connected directly to the mains and so this wouldn't drain the battery). Normally there will be a few more than this, but for now this was all I could find.

### Step 3 – Image zoom

Looking at the PhotoShop File Browser I could see three identical pictures in a sequence – two of them would have to go.

There is no point keeping three shots of the same thing when one will suffice. I selected all three, dragged them into the main PhotoShop window and used Window-Documents-Tile to display them alongside each other (Fig 7.17).

**Fig 7.17**

The image on the left captured a poor expression, so it was deleted. I then re-tiled the two remaining images, zoomed into the eyes with the magnifier tool, and saw that the one on the right was slightly sharper. Standing back it also has a better facial posture, and so I deleted the other. Finally, when all the editing was complete, I had four images left. The final stage was to save each one as a lossless TIFF (Fig 7.18).

This stage is vital to preserve the quality of the original image, although the TIFF is a whopping 31MB file (from my EOS 1Ds), compared to the 5MB JPEG original. This takes more processing power and storage, so it pays to edit them one at a time.

## Step 4 – Load image and convert to 16 bits/channel

In preparation for any colour correction, the TIF is now changed to 16 bits/channel, as seen above (Fig 7.19).

Note that this doubles the file size. PhotoShop needs about four to five times the RAM of an image to process it effectively. If you are constrained by RAM, I suggest that you consider avoiding saving the file as a TIFF and keep it as a JPEG. Changing the JPEG to 16 bits/channel will only increase the file size to 10MB, which is well within the processing power of most workstations. If you take this approach it, pays to plan all your changes and make them all under one maximum-quality save, thus retaining the quality of the image.

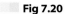 **Fig 7.20**

## Step 5 – Finishing

This is the cleaning and finishing stage, where all the specs of dust, dirt and hairs need to be removed (see pages 158–60 for details). Once cleaning has been completed the image is ready for any manipulation and/or printing in PhotoShop. Image-manipulation techniques are well beyond the scope of this book.

## Pro Tip

**Never save an image that has been sharpened in PhotoShop. This process is irreversible once saved and you will have to start cleaning and pre-processing all over again.**

Before proceeding with manipulation, I suggest that a final 'cleaned' version be saved to 'Digital Finished'. This is vital because any subsequent manipulation in PhotoShop will be irreversible (unless you use the history function), and it is easy to overwrite your cleaned version with a manipulated one.

To save the cleaned image, first convert it back to 8 bits/channel and save as a Maximum Quality JPEG in the 'Digital Finished' file (Fig 7.20). If you intend to do some more manipulation, or are not worried about space, it makes sense to just save it as an 8-bit TIFF instead.

## Step 6 – Move unfinished images to 'Digital Pending'

The final stage of the workflow is to move any unfinished images into the 'Digital Pending' folder.

# RAW Image Workflow

This workflow demonstrates how to develop RAW images into a useable form that can be distributed or printed easily. During this stage I'll still use the editing techniques described in the previous methodologies, as our chosen goal is still to keep only the absolute best. This is particularly important with RAW images due to the extended darkroom time that they need; working on a few good images is a lot more efficient than working on a lot of near misses. This methodology will also introduce a stage for backing up to CD.

As before, I'm using BreezeBrowser for these screen shots, but most browsers should have similar displays. The image-editing tool is PhotoShop 7.0, although PhotoShop Elements would work equally well.

### Step1 – Download image files to workstation

As always the first stage is to drag and drop the images onto the workstation (Fig 7.21).

**Fig 7.21**

The first thing you'll notice is that the RAW numbers are not in sequence. This is my fault. I managed to only take one storage card with me and leave the rest at home, and therefore had to break one of my golden rules and edit in-camera. Luckily I was in my 4x4, and could power the camera directly from the cigarette-lighter socket. Whenever the barn owl was out of range I quickly deleted the shockers, using the LCD zoom and histogram to help me make the decision.

## Step 2 – Delete shockers

The first step is to delete the obvious shockers. Here you can see that I have deleted shots in which the owl is either flying away from the camera or is obviously out of focus (Fig 7.22).

If in doubt, don't delete at this stage. Our editing at the next stage will look more closely at borderline images.

**Fig 7.22**

## Step 3 – Convert all files to JPEG and store in 'Digital Pending' folder

There are many variations to this stage. If you have shot RAW + JPEG images, the slideshow method (see page 135) works well. Otherwise, the following method will yield faster results. The basic remit is to try to determine which of the remaining RAWs are not in sharp focus, and to keep the best of any 'similars'. The latter is probably the most common step as most subjects allow the photographer to take several identical frames, each with subtleties of exposure.

I have found that the quickest way to make these assessments is to convert the remaining RAW images into temporary JPEG files and use the PhotoShop File Browser to edit. (A clever way to avoid this stage, which opens up many other possibilities, is to shoot RAW + JPEG.) Most browsers have a 'batch conversion' option as shown below.

**Fig 7.23**

In Fig 7.23 (previous page) I have selected all the remaining images (CTRL-A), chosen the batch option and set the parameters to 'As Shot'. Remember: at this stage we are not interested in manipulating the shooting parameters. It is much better to do this with a smaller number of RAWs. In the dialog I have specified that I want to generate JPEGs at a quality setting of 95%. The reason that I have chosen to convert them to temporary JPEGs is to save space and reduce PhotoShop load time for the images. This is an important consideration as most people have a normal workstation. The quality of the JPEGs will be perfect for our editing needs. It's also a good idea at this stage to protect the RAWs from any accidents, so the JPEGs are written to the 'Digital Pending' folder.

### Step 4 – Using PhotoShop File Browser to assess images

Use PhotoShop File Browser to view the images in the pending folder (Fig 7.24).

The first images to look at are the 'similars', and this can be done using the Tile technique described on page 136. In this case I have no similars due to the dynamic nature of the bird's flight, so I now check them for focus and exposure (Fig 7.25).

When viewed at 100% it becomes clear straight away that the barn owl's face is far from sharp in the image at the bottom of the screen. I assess all the images on an individual basis, noting down the shockers that need deletion. Once you've seen everything, you should have quite a list of file numbers in front of you for deletion. If not, you are a better photographer than I am!

### Step 5 – Delete all JPEGs in 'Digital Pending'

The last action is to delete the temporary JPEGs in the 'Digital Pending' folder. Hit CTRL-A to select, and delete away (Fig 7.26).

At this stage it is best to close PhotoShop, as this may slow down your workstation.

**Fig 7.24**

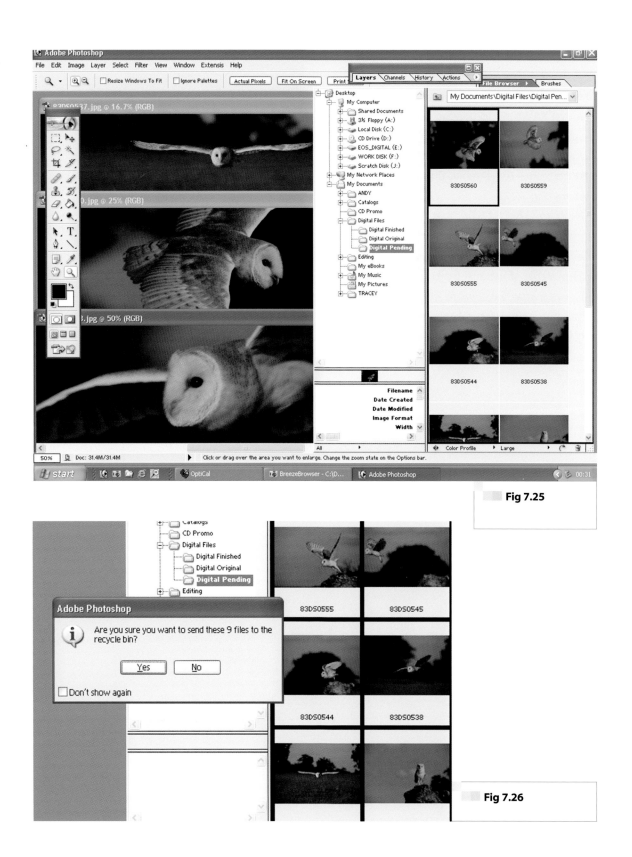

Fig 7.25

Fig 7.26

## Step 6 – Delete unwanted RAW files

Now that the unwanted images have been identified, the next step is to delete the original RAWs using the browser thumbnail display. This needs to be done carefully, but don't worry if you accidentally delete one; just go to the recycle bin, find it and hit restore (Fig 7.27).

Now you should have a much smaller number of RAWs displayed, and these are the ones that we wish to keep (Fig 7.28).

Those that stand out from the others deserve a little extra work. In this case, the superstar is the barn owl taking off from the log, which I shot at 1/4000sec to ensure that the motion was frozen.

**Fig 7.27**

**Fig 7.28**

**Fig 7.29**

### Step 7 – Rename remaining RAWs and back up to CD

Now we have our edited group of RAWs we need to rename them (Fig 7.29).

In my own RAW workflow, this is not an optional step – as a professional photographer, I can easily shoot more than 9999 images in a few months' travelling. Renaming the RAWs at this stage ensures that any converted TIFFs bear the same name as the RAW original; vital if a TIFF is accidentally deleted and needs to be recreated. For some D-SLRs, like my Canon system, the RAW files are given the same .TIF suffix as the converted files. This means it is a frighteningly simple task to overwrite a RAW with a TIFF.

The next action is to back up the RAWs to CD. A RAW file can easily be overwritten, deleted from your hard drive, or lost as a result of hard-drive failure. This may be rare, but it does happen and it is better to be safe than sorry.

### Pro Tip

**Don't be tempted to create a multi-session CD and cram lots of RAWs from different shoots onto it. This creates a potential single point of failure, and can also prove to be a nightmare when trying to find individual RAW files. Remember to make sure that the CD is ISO 9660 too (see page 134).**

**Fig 7.30**

### Step 8 – Converting to 16 bits/channel

Hopefully, most of your remaining RAW images will be exposed correctly and can be converted straight away without any further modification. I call this 'As Shot'. Select all the images that are going to be converted 'As Shot' and batch convert them using your browser options (Fig 7.30).

If you intend to manipulate them in PhotoShop, it is best to convert them as 16 bits/channel, if not 8 bits/channel will be the preferred option. It is now vital to keep the RAWs separate from these converted TIFFs to avoid naming conflicts, so write the TIFFs to the pending folder.

### Step 9 – Adjusting individual images in browser

Now we come to the fun bit: creating the final masterpieces from your RAWs. This is the ultimate developing stage for your RAW image, where you can tweak the shooting parameters and brightness to your heart's content. To illustrate what can be achieved, the following screen shots show the effects of changing some of the shooting parameters on the barn owl image. Hopefully this will encourage you to experiment and start using the digital darkroom to some of its full potential. By default, the browser should be able to preview a RAW image with its original shooting parameters applied (Fig 7.31).

All browsers display shooting parameters differently, but all have one thing in common: changing one or several of the parameters will show a corresponding change in the preview image. Fig 7.32 shows the effect of changing the WB from its shot value (SHADE) to DAYLIGHT. The results are too blue for me, so I can either use the eyedropper to pick a better white balance from the image, change

the colour temperature manually or select another WB value. Browsers like CaptureOne provide a WB magic wand, which generally seems to pick an accurate WB first time.

To show how the parameters can be used together to control the look of the converted image, consider the Colour Matrix parameter. This shot uses the EOS 1Ds equivalent of Adobe 1998, which gives the widest colour

**Fig 7.31**

**Fig 7.32**

**Fig 7.33**

**Fig 7.34**

range and most accurate reproduction. However, in Fig 7.33 we can see what the image would look like with sRGB 3 High Chroma (i.e. Velvia punch).

This gives a reasonably blue sky and a well-balanced image. I know, however, that my clients prefer images that are punchier, with strong colours, so I'll change the WB to SHADE (Fig 7.34). The bluer sky that this creates makes the image a little more commercial, with the

sRGB warming up the colour on the owl. As a result, a minute's effort has changed my RAW image for the better. It would have taken me far longer in PhotoShop because I am not an expert and I wouldn't have been working with raw image data.

Some parameters, however, are difficult to change at this stage – sharpening, for example. It's not that the browser doesn't provide this type of function, but it can be

difficult to see and interpret the results. Sharpening is a gradual process; ideally you need to see the effect of your sharpening on different parts of the image as it is applied. PhotoShop allows you to do this with its 'Unsharp Mask'. Furthermore, it is best to leave the sharpening until the last stage of the workflow, so leave the sharpening untouched at the browser stage.

The final change that I want to illustrate here with the browser is exposure compensation. We have seen previously (see pages 103–7) that a histogram with its average to the left of mid-tone is ideal. The exposure-compensation function of browsers allows you to tweak this slightly. This technique can be shown using the barn owl again (Fig 7.35).

You can see from the histogram that the average is well to the left of centre. I exposed it this way deliberately to stop the white feathers burning out, knowing that I could perform a subtle adjustment, if necessary, using the browser. To get the ideal exposure, the image could do with brightening perhaps one-fifth of a stop, as shown in Fig 7.36.

The histogram has changed a little and the image is clearly slightly brighter. Such a small change could be made in PhotoShop with just the same visual result, but I always prefer

Fig 7.35

Fig 7.36

**Fig 7.37**

to work with the RAW data. I also find that the browser's one-touch approach to colour management saves a lot of time.

The steps that I have shown are only the tip of the iceberg and most browsers allow you to load your own tone curves, adjust the contrast and make all manner of other little tweaks. For most, however, the basics I have covered here are perfectly sufficient; I rarely do any more than this, and my pictures seem to turn out OK.

Once you have corrected the RAW image to your satisfaction, it's time to fully develop it. Select 'Digital Pending' as your destination and either 8- or 16-bit TIFF depending on

your manipulation requirements, then convert and move on to the next image. When you've finished all the RAWs in the directory, it's time to move onto the final developing stage in the workflow – cleaning.

### Step 10 – Cleaning converted TIFFs

The final stage in preparing your converted TIFF is to clean up all the dust specs that the sensor has picked up. Since my favourite barn owl image from above has some very noticeable dust spots, I'll run though a way of getting rid of them for those of you unfamiliar with PhotoShop.

Fig 7.38

Fig 7.39

First, load the image into PhotoShop and make it full screen (Fig 7.37).

Using the magnifier tool to zoom in on the owl, the dust spots become clear, as seen right (Fig 7.38).

With the full version of PhotoShop there are several cleaning options available: the Rubber Stamp, Healing Brush Tool and Patch Tool. For PhotoShop Elements, however, you'll need to make do with the Rubber Stamp, which is what we all used before PhotoShop 7.0 anyway. For this example I will choose the Healing Brush Tool from the Tools palette. Once selected, a size option appears on the action bar. To see if your brush is big enough to cover the dust, place the cursor next to it as shown in Fig 7.39.

For best results the cursor needs to completely cover the dust spot, and ideally

have some extra room too. Here you can see how I have used the slider to increase the size of the brush. Holding down the ALT key allows the Healing Brush to take a sample from the cursor location next to the dust spot, and for the Healing Brush to work well it is best to choose a sample from a similar area. Then just move the cursor over the dust spot, click a couple of times, and it disappears, as shown overleaf (Fig 7.40).

**Fig 7.40**

Repeat this for the entire image; don't leave a single dust spot, as they have an alarming ability to appear very clearly on your prints! At this stage your image is ready for manipulation. It is already in 16-bit mode, so further colour corrections can be carried out immediately. One tip though – save the cleaned image to the 'Digital Pending' folder, overwriting the converted (and uncleaned) TIFF. This effectively becomes your fully developed original.

### Step 11 – Re-convert to 8 bits/channel and save

Manipulation is a personal thing; some digital photographers take images solely to spend hours manipulating, while others take photographs for what they are. My philosophy is to do the minimum to an image, and this barn owl image is finished

without any further manipulation. The final stage, therefore, is to convert the image back to 8 bits/channel (Fig 7.41).

Then save it to the 'Digital Finished' folder (Fig 7.42). Once this is complete – and it should only take two minutes – drag the next image into PhotoShop and repeat the previous two steps.

### Step 12 – Housekeeping

The final task is a housekeeping one. The 'Digital Originals' folder now contains the 'keeper' RAW files that have all been processed. These must be moved from this directory, so that it is empty for new work to be downloaded from the camera. 'Digital Pending' contains temporary TIFF files and they can now be deleted. 'Digital Finished' contains our completed TIFFs, which must now be backed up to CD.

**Fig 7.41**

**Fig 7.42**

# Other Considerations for the RAW Workflow

The RAW workflow outlined above should not be seen as the only way of proceeding. It is merely the way that I edit, and has been included to demonstrate the issues that need to be considered. I learn more about digital photography every day from reading magazines and talking to lots of other photographers, and if I hear a good idea, I'll adapt it to my workflow. The following are a few suggestions that you may be able to use to adapt your workflow accordingly.

## Date-based Directory Structure

The simplistic directory structure used above works fine for most workflows, but for those us who shoot a lot or who hate admin, it can cause some problems. A much better structure is shown below.

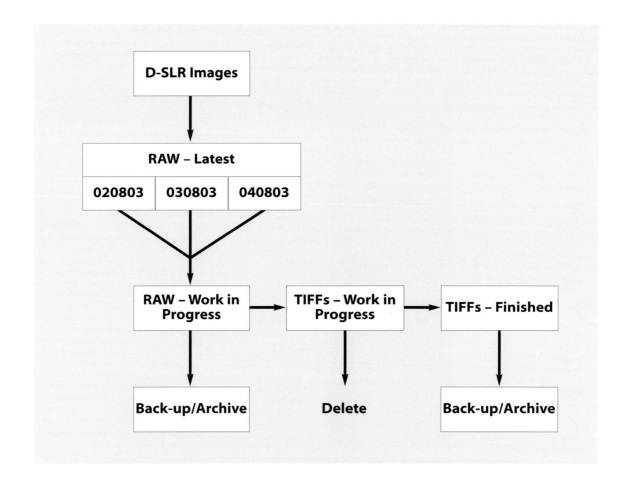

At the top level is a 'catch-all' RAW folder called RAW-Latest, which is the equivalent of the 'Digital Originals' folder mentioned previously. When RAWs are copied straight to the workstation they do not reside in this directory, but rather in a sub-directory inside it that is named with the date stamp, which makes images from a particular shoot easy to find when their turn for editing comes around. More importantly, it prevents any name conflicts. When the editing fancy takes me, I copy all the RAWs from one of these sub-folders into 'RAW: Work in Progress'. I then use the editing process as outlined above, with the converted but yet to be edited TIFFs residing in 'TIFFs: Work in Progress'. When I finish them they move to the final stage, 'TIFFs: Finished', after which both TIFFs and RAWs are backed up to CD. This approach allows me to work in a very methodical manner and leaves room for new RAWs to be added as I shoot them, which can jump the editing queue if necessary.

## PhotoShop Actions

Several digital specialists have written suites of custom PhotoShop actions that perform useful functions when added to

the final stages of a workflow. Mostly these reduce noise, sharpen or widen the dynamic range of an image and they are generally written by extremely talented people. All can be downloaded from the Internet for a small fee, and full details can be found in the appendix (see page 183).

## Ensuring Consistency Between Monitors

If you intend to send out your work to try to earn some cash, perhaps to photographic magazines, it is important to have your monitor colour corrected beforehand. Your image may look great on your monitor, but if it doesn't look good on your client's monitor too, your chances of making a sale are greatly reduced. Simply using an Adobe 1998 ICC profile attached to your picture won't work either, as it is your monitor's brightness and gamma settings that will cause any discrepancies. It may also have a colour cast that is not immediately apparent to you.

There is a choice of colour-calibration products ranging from simple software-based solutions like Adobe Gamma (PC) and Apple Calibrate (Mac), to software and hardware-based solutions like Optical Spyder and Lacie EyeOne. All the programs ask you to make various adjustments to your monitor to match certain targets as they are displayed, and this takes just a few minutes. Once completed, an ICC profile is saved and this describes the characteristics of your monitor to applications like PhotoShop, which make allowances and display a consistent result. More complex systems like Optical use a combination of a software

### Pro Tip

**Before calibrating a monitor, let it warm up for 30 minutes or so and avoid placing it next to a bright window.**

**Pro Tip**

**Try to re-calibrate your monitor every month, and certainly re-calibrate it if you move its position in the room.**

interface and a USB-connected hardware calibrator that fixes onto the screen. These systems are the most accurate as they measure the monitor's performance in detail using various standardized colours, but they come at a price (whereas Adobe Gamma is free with PhotoShop). One point to bear in mind: use either Adobe Gamma/Apple Calibrator or an external calibrator like Optical, but not both.

Once your monitor is calibrated you can be confident that anyone viewing your images on a different workstation will see the same results, provided that their monitor is also properly calibrated.

## Getting Consistent Prints

The perfect print (i.e. one that matches the monitor exactly) is almost impossible to achieve without a lot of hard work and investment in reams of test paper. Most of the time it is just down to luck and persistence. Here are two approaches to printing that could help, one simple and one complex.

### sRGB Workflow
By sticking to an sRGB workflow throughout all your image processing you have a much better chance of getting a print that looks something like what is shown on the

monitor. This means that everything must be set to sRGB – D-SLR Colour Matrix, workstation, PhotoShop workspace and the printer-supplied profile (which is usually sRGB-based anyway).

### Printer-calibrated Workflow
I have a fully calibrated printing system. At the heart of it is a set of ICC profiles specifically generated by a Gretag Macbeth package for the printer paper that I use. To generate the profiles I printed several samples using their supplied 'standard' images, scanned them in with a desktop scanner and fed them into the software. Out the other end came an ICC profile for the paper type. To print I use PhotoShop soft proofing (Proof option) to apply this paper profile to my image before printing. It is a lot of effort just to get a print, and I wonder sometimes is it all worth it. An easier option is to buy and/or download printer profiles from the Internet, which are specific to a printer/paper combination.

**Most of the time I can get nearly the same results using an sRGB workflow as a complex printer-calibrated workflow. In fact, I wonder sometimes why I bother with the latter as the sRGB results are good enough for what I need. At the end of the day, you should choose the option that suits your needs best.**

## ......The Bottom Line

**Fig 7.43**
A real test of my composure, the timing of this shot was a fine line between staying long enough to get what a wanted, but leaving while I still could. The D-SLR (in this case a 1D) ensured that my risk-taking was not wasted, by picking up great detail in very low light.

# Storage, Back-up, Cataloguing and Distribution

# Storage, Back-up, Cataloguing and Distribution

It is inevitable that one day you will accidentally delete a digital image. Whether it is a RAW, JPEG or TIFF, the end result will be that without a good back-up system, all your hard work with the D-SLR workflow will be wasted. As I've stated several times in this book, using a D-SLR will greatly increase the number of pictures that you take. This means that the management and cataloguing of images will quickly outgrow any home-grown or spreadsheet solution. This chapter presents some examples of third-party software that can greatly improve your cataloguing techniques without taking up excessive amounts of your precious spare time. Finally, I've included a section on distributing your images, whether to potential clients or family members on the other side of the planet.

## Storage and Back-up Considerations

If you followed the workflows of the previous chapter, you will now have a collection of RAW/TIFF or JPEG masterpieces that need to be stored somewhere. There are several choices: workstation hard drive, CD/DVD, or external hard drive.

The problem with backing up is that it is seen as administration – a boring task that takes up valuable picture-taking time. In my experience, most photographers only consider backing up as an option once they have already lost something. Backing up your image data, whether JPEG, RAW or TIF, is a necessary evil of digital photography. It can be made as simple or as complex as you need. My advice is to keep it simple and obvious, but remember: backing up data is not simply a case of copying it to CD and deleting the original; a back-up is a file that is kept separately from the primary storage of the file.

## Workstation Hard Drive

The workstation hard drive seems the obvious place to store images initially, and it will probably work fine for most hobby photographers shooting JPEGs. After all, 1000 JPEG-FINE images (approx. 2MB in file size each) will only take up 2GB of hard-drive space, which on an 80GB drive is not that much. However, building up a large stack of images can degrade workstation performance by taking up valuable storage space. My advice for JPEG shooters is to start off by using the workstation hard drive, then, if storage becomes a problem, use one of the methods outlined overleaf.

**Fig 8.1**
**A beautiful roe buck in very late sunlight. Such encounters are priceless, hence my paranoia about backing up images.**

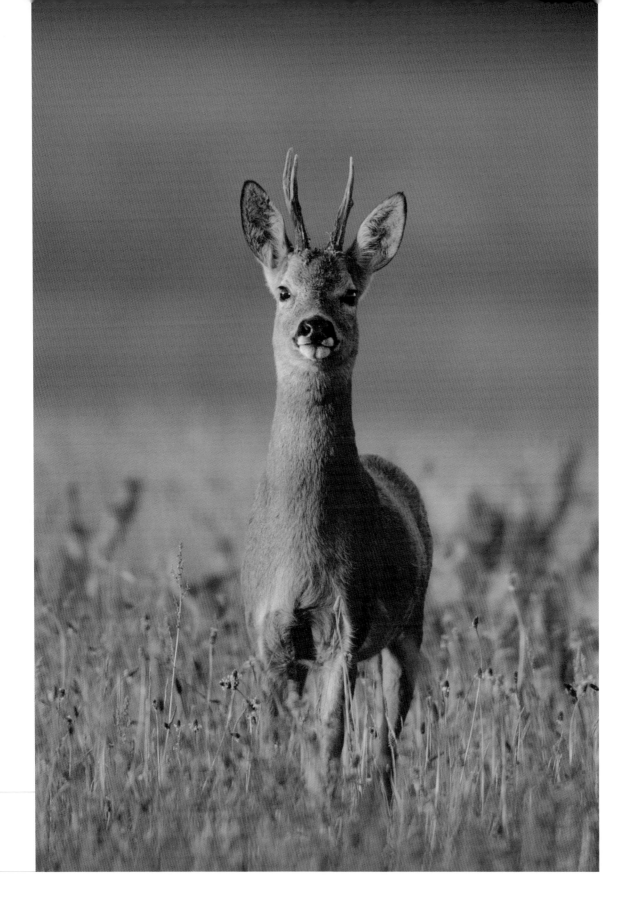

RAW shooters need to aware of this issue straight away. The combination of a RAW and a TIFF file from a 6.3MP camera is approximately 23MB, 1000 of which will take up 23GB of disk space – slightly more alarming. It's also a recipe for disaster having RAWs and TIFFs stored on the same hard drive.

## CD/DVD

I know some photographers whose solution to the storage problem is simply to ship out all their RAWs, TIFFs and JPEGs straight to CD or DVD, and have nothing stored on the workstation hard drive. This is a good strategy as it helps to solve some of the problems outlined above, but there are a couple of negative issues:

■ Consistent use of a CD will cause it to degrade more rapidly, as well as leaving it prone to further accidental damage such as scratches.

■ It is easy to build up a large stack of CDs, and finding the one that you want can become a real hassle.

Fortunately there is an elegant solution to the second point. The basis of any back-up system needs to be a numbering system for CDs, so that you know exactly what is on a certain disc. At its simplest, a back-up strategy could be to write the names of all the files contained on that disc on the CD insert. The problem with this approach is that it quickly becomes overly difficult to sort through piles of CDs looking for a particular image. Fortunately, companies such as Adobe and Extensis offer

**Fig 8.2**
**I deliberately underexposed this shot of a singing robin as I wanted to ensure that the bright feathers on its side did not burn out and the background did not become distracting.**

visual image-management products that greatly simplify back-up, cataloguing and management in general. These will be covered in more detail below (see page 173).

The next level of backing up is to use DVDs, which have a capacity of 4.7GB, compared to 700MB on a CD. The big advantage of using DVD is that you will have a lot fewer CDs hanging around, but the risk of having so much information contained in one place was outlined earlier (see page 51). A further disadvantage is that the large capacity of a DVD will encourage you to wait longer to back up data so that you can fill a whole one. This may take several weeks, or even months, which defeats the object of making back-ups in the first place. If you want to utilize DVDs for back-ups, you'll need to buy a separate writer. There are several varieties of DVD available, so be careful to get the one that you need. DVD-RAM seems to be increasingly popular for back-ups as it is a re-writable cartridge rather like a ZIP drive.

Speaking from a personal level, I consider CDs and DVDs to be an excellent back-up option, but I wouldn't use them as my primary storage tool. However, because I rely on my images for my living, I am particularly paranoid about losing my images. For most photographers, especially those following the JPEG workflow, the CD/DVD route would be a satisfactory option.

## External Hard Drives

For those of you who, like me, want the best 'affordable' storage solution (as opposed to a RAID system, which costs thousands of pounds), an external hard drive is the best option. Ranging in size from 80–500GB, and connecting to your PC using either USB 2.0 or Firewire, these drives offer the ultimate in flexibility. They are only marginally slower than an internal hard drive, and can be connected and disconnected at will. I currently have seven 125GB Firewire drives, six of which are used specifically to store TIFFs and one for RAWs. For most users, this would be totally excessive, and single 125GB drive should be sufficient for many years of photography. External hard drives do present some problems, though. Here are some tips that I have learnt the hard way:

**Fig 8.3**
**Before I used a D-SLR, I would never have tried to shoot a dark subject against the light. When this wildebeest started running around, I had the confidence to shoot it with my 1D, and was rewarded with a good action picture.**

■ manufacturers suggest that the drives are stackable – i.e. you can store them on top of each other. I do not recommend this, unless you want to fry eggs on your drives, as they can generate a lot of heat and this can (and probably will) lead to failure. If you have multiple drives, site them separately

■ hard drives are not designed to be moved around – do so and you're asking for trouble

■ when disconnecting the drive from Windows, it pays to ensure that you use the Safely Remove Hardware option from the taskbar. This can help to prevent any disk problems

■ only power up drives when you need to use them, and make sure that they are connected to the power source before inserting the Firewire or USB cable. When you've finished using the drive, disconnect safely as suggested above.

All hard drives can fail, and external ones are no exception. Recently, the drive containing all my unprocessed RAWs failed – one minute it was there, the next it wasn't. The manufacturers offer a three-year warranty, which is great for replacing the equipment, but not so great for recovering the data that remains stored on it. I called several data-recovery companies, who offered to retrieve my data from the defective drive for a large fee. Just as I was about to resign myself to paying, a colleague told me about a data-recovery shareware product called PC Inspector. Within five minutes of

downloading it from the Internet, it was starting to recover my files from the stricken drive, and within a day it had recovered everything. Details of the website can be found in the appendix (see page 183).

# Cataloguing Your Images

In the old days of slides, it was relatively easy to find your images. All you had to do was to pull open the relevant draw of the filing cabinet and put a bundle of slide wallets on the light box. Not much has changed in the digital age, except that the filing cabinet has been replaced by cataloguing software on your workstation. The main problem when managing digital images is remembering where you put them in the first place. If you've chosen to run everything from CD, it will quickly become a nightmare trying to find the CD with the images that you want. Of course, if you have relatively few images to manage, your PhotoShop/Elements file browser will do a fine job, but very quickly you'll need something a little more advanced.

Several vendors market software that allows you to catalogue and arrange images using keywords, dates and so on. Depending on the package you choose, these images can then be arranged in galleries, distributed on the web or made into calendars and cards. However, the main benefit of this software is that it is location independent – provided you allow the software to catalogue the image, it will always know where it is stored. This is very useful when dealing with CDs, either as back-ups or primary storage locations, as your

management of the images will be visual rather than requiring a time-consuming search of drives and directories. It can cause a problem if you change the location of a file and don't tell the software, but it is generally sophisticated enough to work this out and prompt you to find a new location.

To show what can be achieved with these products, here are a few simple applications using two of the most common programs, Adobe PhotoShop Album and Extensis Portfolio.

This screen shows a typical Adobe PhotoShop Album display of some of my latest work, taken in Africa. Selecting an image, such as the hippo, allows caption data and descriptions to be added to the image, plus any tags that will be used later for searching.

## Adobe PhotoShop Album

This is a feature-rich product that provides basic yet functional image management via an easy-to-use graphical interface. As well as the basics, Album provides some nice web applications, screen shows and the ability to produce your own cards and calendars.

Album has a great archive capability whereby you can specify images to be written to CD, but with a thumbnail still retained on the hard disk. If you need the full-sized image, you'll be directed towards the CD that you created, which is why it pays to think of a clever naming standard for your CDs, particularly if you choose them as your primary storage location.

Our database is arranged by species group, so we have galleries of lions, chimpanzees, and so on. They are all linked by keywords, such as 'cute', so a single search will bring up results for many different species.

## Extensis Portfolio

**Although I use some PhotoShop Album functions, my main library management tool is Portfolio, which currently catalogues over 15,000 of my images. Portfolio is totally scalable and provides an integral search engine that powers my searchable website.**

**You can see from the screen shot that I use Portfolio to catalogue the location of the back-up CDs for both RAWs and TIFFs of each image. The custom fields shown are very simple to set up and can save days of work in the event of a failure.**

# Distributing Images

Before I cover the methods that you can use for distributing images, I should perhaps outline some copyright issues that you need to be aware of before sending your images out to anyone.

## Image Copyright

International copyright law states categorically that as the photographer you own sole copyright of the image. This means that for anyone to reproduce your image in any way (in a magazine or on a website, for instance), they have to obtain your permission first. This is well known in the photographic industry, but you should not take it as a guarantee that your images will never be shown without your permission. With the advent of photographer websites, the potential for image misuse has risen alarmingly. Several times in the last year I have been told about images of mine appearing on websites throughout the world,

**At the end of the day, if someone wants to misuse one of your images, they will, no matter how many precautions you take. But if you follow the steps outlined here, the chances and impact of misuse are greatly reduced and give you a legal standing.**

## ......The Bottom Line

### Pro Tip

**If you're displaying an image on the web, or sending one via email, make it large enough to be seen well, but too small to be used commercially. If someone wants to see a bigger file, they can ask for it and you can find out more about their intentions. This is very simple to do in packages such as Adobe PhotoShop.**

and on each occasion I have spoken to the webmaster and arranged for their immediate removal. It's not that I am particularly touchy about the use of my images (I'm pleased to help out several animal charities by allowing them to use my work for free), but I will not

### Pro Tip

**To protect images further, a lot of photographers place watermarks across them. A watermark is a slightly opaque phrase, usually the copyright symbol (©) and a name, that is written over the top of the image. This method is generally used to prevent unauthorized usage on other websites, or in composites in presentations. The key is to place the watermark over a significant portion of the image, just enough to prevent its misuse, but not enough to spoil the impact of your masterpiece.**

tolerate the use of my images without express permission. We all need to be aware of copyright abuse. To limit the chances of your

images being misused, you can take a few simple steps, as shown in the following screen grabs.

*Protecting Your Images*

Here is one of my EOS 1Ds images. At 300 dpi, the file is 31MB. More importantly, its print size is getting towards A3. If I were to put this full-sized image on the web, you can bet that it would start appearing as a bootleg poster within a couple of weeks.

By reducing the longest side to 600 pixels, the print size is drastically reduced and the file size is only 701KB. This is still too large, so I usually save as a JPEG Compression Level 5, which in this case yielded a 28KB file. An alternative method would be to reduce the image resolution from 300 to 72dpi (a change that would not be visible to the human eye anyway). The resulting small file size will be much easier to send by email and much quicker to upload and display on the web.

# Creating Web Galleries

The Internet has provided us with a great resource to show our photographic work. The problem is that until recently it required at least some knowledge of HTML and/or JavaScript. Now there are several packages that allow you to generate simple web pages

**Fig 8.4**
Some RAW browsers provide excellent web-generation functions. Here is a typical web page generated by BreezeBrowser, which took all of 30 seconds to complete. Clicking on the thumbnails will display a watermarked, slightly larger image – a really nice and simple implementation to show your work. With some very limited HTML knowledge this could easily be expanded into a website featuring a number of pages.

**Fig 8.5**
Adobe PhotoShop Album provides some great web templates too, but my favourite is the Atmosphere gallery. Using specified images and some great themes, you can display a 3-D gallery that you use the cursor to walk round – complete with musical accompaniment! It's a really fun tool and provides a neat way to set up your own online exhibition quickly and easily, complete with picture captions.

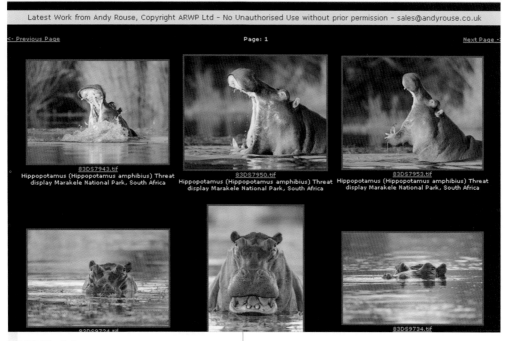

Latest Work from Andy Rouse, Copyright ARWP Ltd – No Unauthorised Use without prior permission – sales@andyrouse.co.uk

<- Previous Page                    Page: 1                                    Next Page ->

83DS7943.tif
Hippopotamus (Hippopotamus amphibius) Threat
display Marakele National Park, South Africa

83DS7950.tif
Hippopotamus (Hippopotamus amphibius) Threat
display Marakele National Park, South Africa

83DS7953.tif
Hippopotamus (Hippopotamus amphibius) Threat
display Marakele National Park, South Africa

83DS9724.tif

83DS9734.tif

**Fig 8.6**
**I often use the web-creation feature of Extensis Portfolio to create a small web page of my latest images. I can then quickly upload it and send clients an email with a link to the page. I find that this method works much better than sending out work speculatively on CD, as most clients have direct connections to the Internet and can view the page within seconds.**

quickly and easily, allowing you to upload your images and make them available to the world within minutes. I have used this method many times with clients in remote countries, on occasions when sending them a CD would take several days. On a more personal level, it's great for showing relatives your family pictures, sharing your latest masterpieces with other members of your photographic club, or simply advertising yourself to the world!

**And so we have reached the end of our D-SLR workflow and also the book. I hope that I have given you a flavour of how to use your D-SLR effectively and that this book will help improve the quality of your pictures. We all learn every day, and I am the first to admit that my photography improves every time I use the camera. Don't be afraid to share ideas with other photographers. Perhaps the best way is to join your local photographic club and speak to like-minded people. There is a whole world out there waiting to be photographed, and you have just the tool to do it.**

# ......The Bottom Line

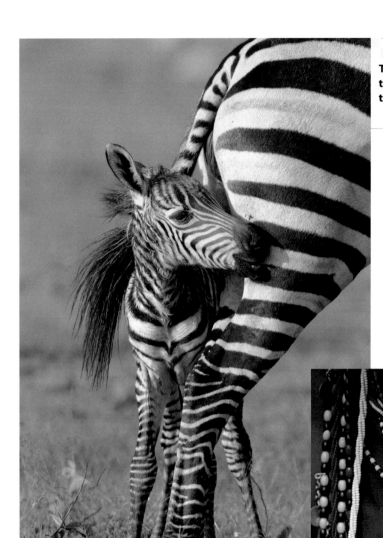

**Fig 8.7**
This portrait of a newborn zebra in
the Masai Mara was surprisingly easy
to expose for using a D-SLR.

**Fig 8.8**
The punchy colours of an sRGB colour space/matrix
profile (see pages 82–4), coupled with a WB of
SHADE (see pages 74–9) help this Masai jewellery
to really stand out.

**Fig 8.9**
To create this motion trail of a captive Harris hawk, I used a combination of a slow shutter speed (1/30sec) and a second curtain sync flash. It is easy to experiment like this with a D-SLR, where, unlike using film capture, you can do so without incurring any processing costs (except for time spend at a workstation editing the images from a shoot).

# Appendix

A selection of useful websites for digital photographers:

**www.wyofoto.com** For details of the mathematical analysis used in Chapter 1 (see page 22)

**www.foveon.com** For details of the Foveon sensor (see pages 32–3)

**www.four-thirds.com** For details of the Four Thirds digital standard (see pages 36–7)

**www.robgalbraith.com** For lively forums, technical discussions and up-to-date information

**www.warehouseexpress.com** For technical reviews (by author) and digital retail

**www.andyrouse.co.uk** The author's own website, with searchable database, newsletter, noticeboard, and further information on much of the digital equipment mentioned in this book

**www.actions.home.att.net** For Noel Carboni's PhotoShop actions

**www.fredmiranda.com** For Fred Miranda's PhotoShop actions plus lively forums and good general digital information.

**www.breezesys.com** For the BreezeBrowser software

**www.adobe.com** For details of Adobe products such as PhotoShop, RAW, Elements and Album

**www.extensis.com** For details of Portfolio and other products

**www.pcinspector.de** For details of a useful recovery program for stricken hard drives

**www.c1dslr.com** For the CaptureOne DLSR RAW conversion software

**www.dpreview.com** For technical reviews

**www.luminous-landscape.com** For product reviews and great information

**Fig 8.10**
This shot was a challenging one as I wanted to included both parties in the frame, but have the main focus on the snake. The stunning markings on the back of the snake's head gave me the idea, so I laid down flat on the ground (out of striking distance, I might add), focused on the swaying cobra, and set an aperture of f/4 to blur out the charmer. The light was awkward, being in semi-shade, so I selected a Daylight WB to reduce the colour cast. Of course, I could have asked for the snake to be moved into the sun, but decided that irritating it further was not a good idea if I wanted to stay healthy!

# Glossary

**Aperture** A small, circular opening inside the lens that can change in diameter to control the amount of light reaching the camera's sensor as a picture is taken. The aperture diameter is expressed in f-stops; the lower the number, the larger the aperture. For instance, f/2.8 creates a larger opening than f/8. See also shutter speed.

**Application** A computer program, such as an image editor or image browser.

**Buffer** Memory in the camera that stores digital photos before they are written to the memory card.

**Burning** Selectively darkening part of a photo with an image-editing program.

**CCD** Charge Coupled Device: one of the two main types of image sensors used in digital cameras. When a picture is taken, the CCD is struck by light coming through the camera's lens, in the same way that would strike film.

**CD-R** CD-Recordable: a compact disc that holds up to 700MB of digital information. Creating one is commonly referred to as burning a CD. A CD-R disc can only be written to once, and is a good storage medium for digital photos.

**CD-RW** CD-Rewritable: similar in virtually all respects to a CD-R, except that a CD-RW disc can be written and erased many times. This makes them best suited to many back-up tasks, but not for long-term storage of original digital photos.

**CMOS** Complementary Metal-Oxide Semiconductor: one of the two main types of image sensors used in digital cameras. Its basic function is the same as that of a CCD.

**CMYK** Cyan, Magenta, Yellow, Black. The four colours in the inksets of many photo-quality printers. Some printers use six ink colors to achieve smoother, more photographic prints.

**CompactFlash** A common type of digital camera memory card, about the size of a matchbook. There are two types of cards, Type I and Type II. They vary only in their thickness, with Type I being slightly thinner.

**Dodging** Selectively lightening part of a photo with an image-editing program.

**Download** The process of moving computer data from one location to another. Though the term is normally used to describe the transfer, or downloading, of data from the Internet, it is also used to describe the transfer of photos from a camera memory card to the computer.

**Firewire** A type of cabling technology for transferring data to and from digital devices. Some professional digital cameras and memory card readers connect to the computer over Firewire. Firewire card readers are typically faster than those that connect via USB. Also known as IEEE 1394, Firewire was invented by Apple but is now commonly used with Windows-based PCs as well.

**Histogram** A graphic representation of the range of tones from dark to light in a photo. Some digital cameras include a histogram feature that enables a precise check on the exposure of the photo.

**Image browser** An application that enables you to view digital photos. Some browsers also allow you to rename files, convert photos from one file format to another, add text descriptions, and so on.

**IBM Microdrive** An alternative form of digital-image storage media to a CompactFlash card. A Microdrive is literally a miniature hard drive, unlike a CF card, which uses solid-state technology.

**Image editor** A computer program that enables you to adjust a photo to improve its appearance. With image-editing software, you can darken or lighten a photo, rotate it, adjust its contrast, crop out extraneous detail, remove red-eye and so on.

**Image resolution** The number of pixels in a digital photo is commonly referred to as its image resolution.

**JPEG** A standard for compressing image data developed by the Joint Photographic Experts Group, hence the name JPEG. Strictly speaking, JPEG is not a file format, it's a compression method that is used within a file format, such as the JPEG format common to digital cameras. It is referred to as a lossy format, which means some quality is lost in achieving JPEG's high compression rates. Usually, if a high-quality, low-compression JPEG setting is chosen on a digital camera, the loss of quality is not detectable to the eye (see pages 59–63).

**LCD** Liquid Crystal Display: a low-power monitor often used on the top and/or rear of a digital camera to display settings or the photo itself.

**Megabyte (MB)** A measurement of data storage equal to 1024 kilobytes (KB).

**Megapixel** Equal to one million pixels.

**Pixel** Picture Element: digital photographs are comprised of millions of them; they are the building blocks of a digital photo.

**RAW** The RAW image format is the data as it comes directly off the CCD, with no in-camera processing performed.

**RGB** Red, Green, Blue: the three colours to which the human visual system, digital cameras and many other devices are sensitive.

**Saturation** How rich the colours are in a photo.

**Serial** A method for connecting an external device such as a printer, scanner, or camera, to a computer. It has been all but replaced by USB and Firewire in modern computers.

**Shutter speed** The camera's shutter speed is a measurement of how long its shutter remains open as the picture is taken. The slower the shutter speed, the longer the exposure time. When the shutter speed is set to 1/125 or simply 125, this means that the shutter will be open for exactly 1/125th of one second. The shutter speed and aperture together control the total amount of light reaching the sensor. Some digital cameras have a shutter priority mode that allows you to set the shutter speed to your liking. See also aperture.

**Thumbnail** A small version of a photo. Image browsers commonly display thumbnails of photos several or even dozens at a time.

**USB** Universal Serial Bus: a protocol for transferring data to and from digital devices. Many digital cameras and memory card readers connect to the USB port on a computer. USB card readers are typically faster than cameras or readers that connect to the serial port, but slower than those that connect via Firewire.

**White balance** A function on the camera to compensate for different colours of light being emitted by different light sources.

# About the Author

Andy Rouse is a professional photographer renowned worldwide, through his television series *Wildlife Photographer*, for getting up close to dangerous animals. The author of five previous titles, including *Life in the Wild: A Photographer's Year*, Andy also writes columns on photography and digital imaging in several photographic magazines. His prints are published in many countries, including the USA, UK, Germany and Japan, and more of his work can be seen at: **www.andyrouse.co.uk**

## With Thanks

Special and heartfelt thanks must go to the following people; they have helped, supported and encouraged the production of this book:

PVV (for being my digital inspiration), Andrew Jackson (ACTPIX), Peter Madeley, Leo and Carolyn Rich, Andrew James (PP), Stuart Porter, Colin 'moth goth' Langdon (Adhoc Hairdressers), Howard Utting and Ainsley Wilkins (Warehouse Express), Paul Burgman, Elaine Swift (Nikon), Safdar Zaman and Barry van Vuuren (Canon), Chris Breeze, Jane Nicholson (Intro 2020), Tim McCann (DPME), and all those involved with this project at PIP.

# Index